Optical Illusions

ST. HELENS COLLEGE LIBRARY

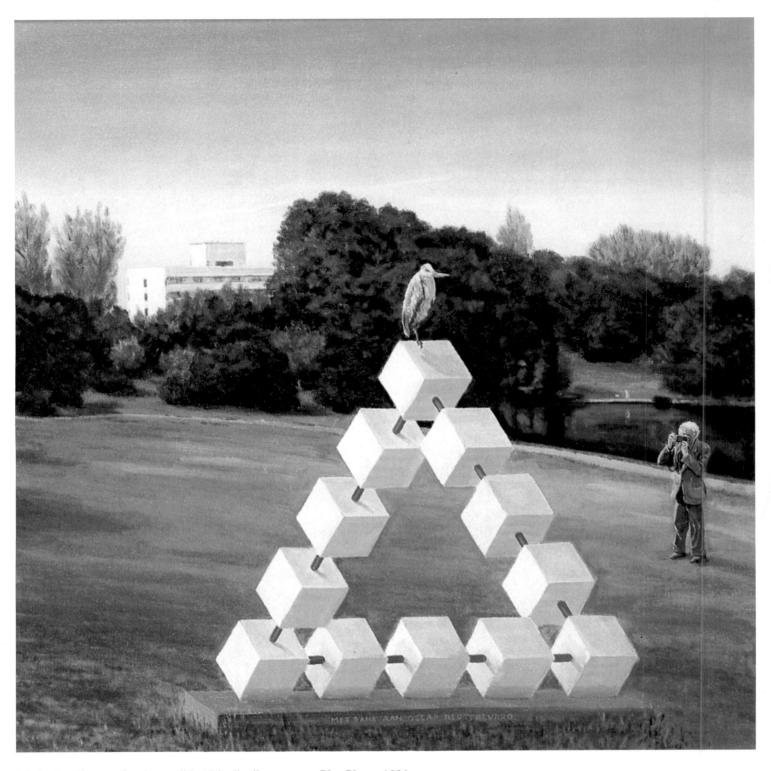

1 Léander, "Statue of an impossible tri-bar", oil on canvas, 70 x 70 cm, 1984

Bruno Ernst

Optical Illusions

TASCHEN

KÖLN LISBOA LONDON NEW YORK OSAKA PARIS

Back cover:

Jos de Mey

Carefully-restored Roman ruin in a forgotten

Flemish locality with Oriental influences, 1983

Source of illustrations:

Unless otherwise indicated, the illustrations in this book stem from the archive of the author or the publisher. The following drawings were provided by Artidee, Alkmar: p. 6/ill. 3, 7/5, 10/12, 17/11, 24/8, 25/10–12, 29/18, 31/24–25, 32/27–30, 36/6–7, 37/9, 48/3–4, 49/6, 50/6, 51/10, 55/22–23, 58/32–34, 64/53, 66/57, 73/9–11, 91/2.

Photographic acknowledgements:

Bayerische Staatsbibliothek, Munich, p. 68 left,

K. de Boer, Academische Ziekenhuis, Maastricht, 12/3,

Studio Bokma, Amsterdam, 93/6-8,

Pieter von der Meer, Rotterdam, 49/5, 53/17, 56/25, 35/4,

Jan Minnaard, Utrecht, 38/11,

Rolf ter Veer, Breda, p. 68 right,

A. J. W. M. Thomassen, Nijmegen, 18/12.

Permission was kindly granted by the copyright holders for the reproduction of the following:

11/1 (© Ciba-Geigy Corporation) and 11/2 from: R.G. Kessel and R.H. Kardon, *Cellen, weefsels en organen*, Natuur en Techniek, Maastricht-Brüssel 1983,

12/4, 13/6, 18/12, 19/13–14, 20/15–16 from: D. Marr, *Vision. A Computational Investigation into the Human Representation and Processing of Visual Information*, W. F. Freeman and Company, San Francisco 1982, (12/4, 18/12 and 19/13 © 1986 Department of Electrical Engineering and Computer Science, Massachusetts Institute of Technology, Cambridge, Mass.; 19/14, 20/12–13 © 1986 The Royal Society, London), 13/7 from: *Meaning, Use and Interpretation of Language*, Walter de Gruyter, Berlin/New York 1983, 31/25, 41/15–16 (© 1986 Mitsumasa Anno) from: *The Unique World of Mitsumasa Anno: Selected Illustrations 1968–1977*, Kodansha Ltd., Tokyo 1977.

This book was printed on 100 % chlorine-free bleached paper in accordance with the TCF standard.

Originally published as "Het begoochelde oog"

- © 1986 by Bruno Ernst
- © 1992 Benedikt Taschen Verlag GmbH Hohenzollernring 53, D-50672 Köln
- © 1989 for all M. C. Escher illustrations: Cordon Art, Baarn, Holland English translation: Karen Williams, London Cover design: Mark Thomson, London

Printed in Germany ISBN 3-8228-9637-3 GB

Contents

1	Introduction: Impossible objects	
	and ambiguous figures	7
2	Vision as data-processing	11
3	Ambiguous figures	21
4	Impossible objects	33
5	A gallery of impossible objects	47
6	Origins and history	69
7	Models	91
	Bibliography	94
	Divingsupity	77

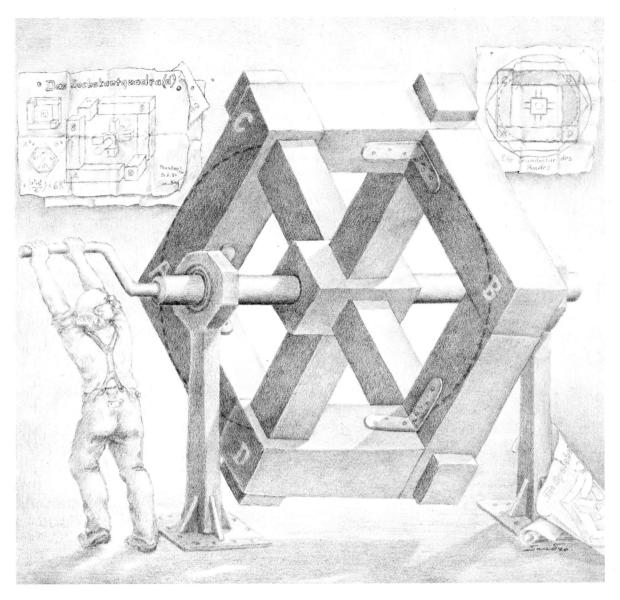

2 Sandro del Prete, "The quadrature of the wheel", pencil drawing

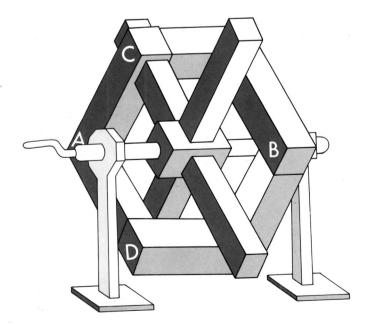

Figure 3

1 Introduction: Impossible objects and ambiguous figures

The author of the drawing opposite (fig. 2) has combined considerable mathematical imagination with a generous portion of technical skill to produce a new type of flywheel. Its individual components are detailed in the plans pinned to the wall on the left, while the frontal view of the axle hanging on the right reveals the design of a quadratic wheel. But the viewer remains rightly unconvinced: no such wheel can be built. There is nothing impossible about the six beams composing the outer rim of the wheel, even though they do not lie within the same plane, but the four spokes simply cannot be attached as shown. The inventor of this particular wheel challenges us to find even one join within the entire composition which is demonstrably false. But as we soon discover, all are correct. And yet . . . the object illustrated here in such precise detail cannot exist in space: it is an impossible object! Only by separating the joins at certain points do we arrive at an object which can indeed be built - Figure 3 shows one of the possibilities. The result, however, is something entirely different to what the inventor originally intended: a bizarre three-dimensional construction whose possibility has left it useless . . .

Sandro del Prete has incorporated two impossible tri-bars into this "impossible wheel". The tri-bar is the simplest and at the same time the most fascinating of all the impossible objects we know (fig. 4). It looks very "real", and yet it cannot exist. It is a most peculiar no-thing.

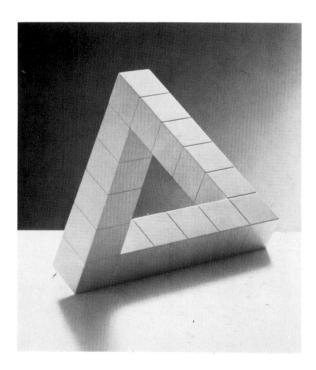

Yet its impossibility is not as absolute as that of a square circle, for example, which can neither be imagined nor drawn. The impossible objects with which we are concerned can, strangely enough, be easily visualized, wherein lies their attraction. They open up a new world and thereby illuminate something of the incredibly complex process that we call

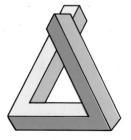

4 Oscar Reutersvärd, Impossible tri-bar

Figure 5

vision. Is an impossible tri-bar *really* impossible? Figure 5 shows how, by separating the arms of such a tri-bar at certain points, we arrive at an object that can be built; it is immediately obvious that we have thereby transformed it into something entirely different.

Sandro del Prete's *Three Candles* (fig. 6) represent a very different category of impossible object to that of the impossible tri-bar. Are there three candles, or just two? If we lower our eyes from the middle flame, we find the candle on which it is burning fades mysteriously into nothing. At the same time, if we

raise our eyes from what appears to be the square base of the right-hand candle, we find that its left-hand side vanishes into the background, so that only the right side remains. A characteristic feature of such impossible objects is that they can only be rendered in black and white; they cannot be coloured in. Three further drawings by Oscar Reutersvärd are also reproduced on this page (figs. 7-9). There is something positively irritating about such images, in which the figure which initially appears so solid slips away beneath our very eyes. Matter seems to vanish into void.

Ambiguous figures form a different category again. In contrast to impossible objects, which do not exist and which represent nothing, ambiguous figures may suggest more than one three-dimensional reality at once. Thus we can interpret the figure at the centre of Monika Buch's painting (fig. 10) as both a cube projecting outwards and a concave cubic space. It would be perfectly possible to design and build two different three-dimensional models of the picture, one illustrating each interpretation. As we shall see in Chapter 3, every image projected onto the retina of the eye is essentially ambiguous, whether we are looking at a picture or at real objects around us. Fortunately, this rarely causes us problems in everyday life, since our consciousness accepts only those of the many pieces of information provided by the image on the retina which correspond with reality. We only speak of ambiguous figures where two (and sometimes even more) interpreta-

6 Sandro del Prete, "Three candles", pencil drawing

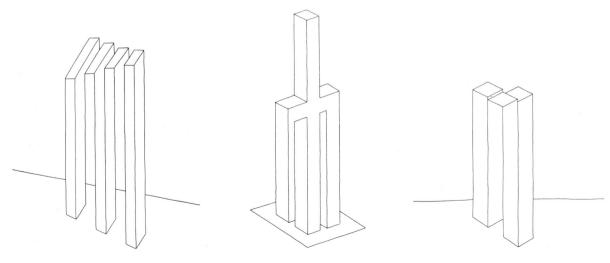

7-9 Oscar Reutersvärd

10 Monika Buch, "Illusory cube", acrylic on fibreboard, 60 x 60 cm, 1983. Three large bars, themselves each composed of twenty-five small bars, form a "concave cube" After a few seconds, this suddenly inverts into a convex cube. Before the EYE switches back to the first, concave interpretation, we are able to see how the thinner bars are transformed into transparent streaks, like shafts of coloured light, illuminating the cube from three sides.

tions of one and the same figure are plausible.

The first scientists to make a study of impossible objects and ambiguous figures listed both categories under the heading of "optical illusions". This is somewhat misleading, however, since in this way the unique character of such objects is overlooked. Optical illusions are things which we see but which either do not exist in reality or whose real nature is different. We regularly encounter optical illusions in our daily lives without recognizing them as such, simply because we are constantly making allowances for them. For example, although the moon may appear to follow us as we walk down the street at night, we know full well that it is actually standing still. Similarly, the moon appears much bigger when low on the horizon than it does when high in the sky,

but we do not therefore think the moon expands and contracts every night. When I look out of my window down onto the houses below, they appear no larger than the jar on my windowsill, yet I give the phenomenon no second thought. Optical illusions are for the most part an integral aspect of our perceptual expectations.

Certain forms of optical illusion nevertheless possess an unusual character; some are even named after their "inventor" or discoverer. In a painting by Prof. A.J.W.M. Thomassen (fig. 11), we see, amongst other things, the Sander parallelogram (1926; fig. 12). If this particular optical illusion is new to you, take a ruler and measure for yourself the difference between the long AB line and the short BC line! The Fraser illusion (1908; fig. 13) demonstrates the large extent to

11 A.J.W.M. Thomassen, "Anachronistic psychological laboratory", 1975

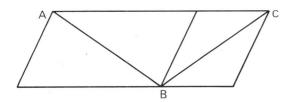

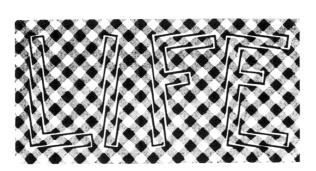

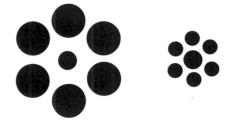

which the direction of lines is determined by additional factors: although the letters of the word LIFE appear to lie crooked, they in fact stand vertical and parallel. Judging the size of a circle is equally dependent upon the objects surrounding it (Lipps, 1897; fig. 14): the centre circles in the two patterns are both the same size.

Such optical illusions have been the subject of research for over one hundred and fifty years, and they have much to teach us about the functioning of our sense of sight. The ambiguity of figures was discussed by Necker as early as 1832, although impossible objects only began to attract attention from 1958 on, through the work of Penrose and his son, whose impossible tri-bar also features in Thomassen's painting.

In this book we shall be showing, amongst other things, that ambiguous figures and impossible objects are important not simply for the peculiar light which they throw upon the phenomenon of vision, but because their discovery by artists has opened up previously unexplored fields in the history of art.

12 The Sander illusion

13 The Fraser illusion

Figure 14

2 Vision as data-processing

Impossible objects and ambiguous figures are not things that can be handled in the literal sense: they arise in our brain. Since the perception process in the case of these figures follows a strange, non-routine pattern, the viewer becomes aware that some-

thing is happening inside his head. For a better understanding of the process that we call "vision", it is useful to have an idea of the manner in which our sense of sight (our eyes and our brain) processes light stimuli into meaningful information.

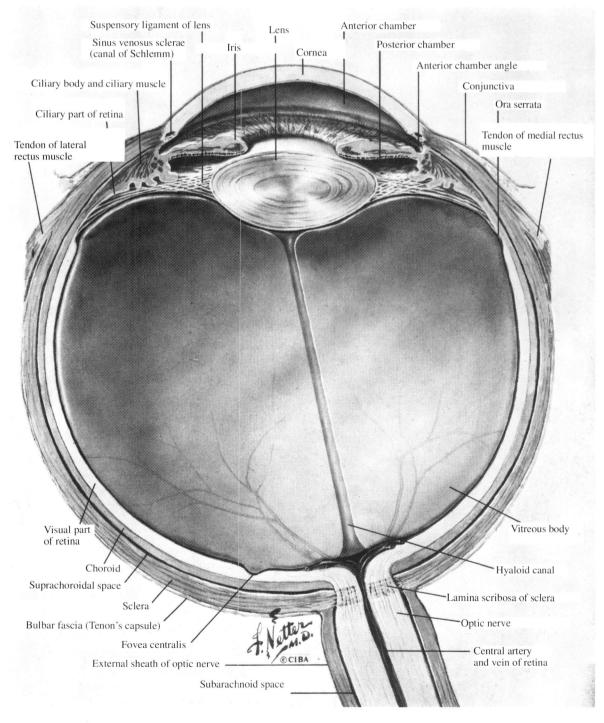

The eye as optical instrument

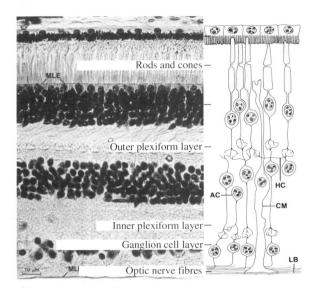

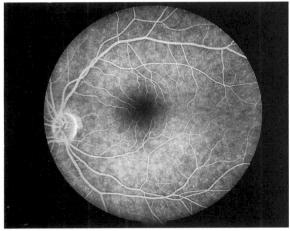

The eye (p. 11, fig. 1) works like a camera. The lens projects a reversed, reduced image of the outside world onto the retina – a network of photosensitive cells, lying opposite the pupil, which occupies more than half the interior of the eyeball. As an optical instrument, it has long been recognized as a small miracle. Whereas a camera is focused by moving the lens either closer to or away from the photosensitive layer, in the eye it is the refractive power of the lens itself which is adjusted during accommodation (adaptation

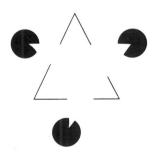

to a specific distance). The shape of the eye lens is modified by means of the ciliary muscle: when the muscle contracts, the lens becomes rounder, whereby a focused image of nearby objects is cast onto the retina. The aperture of the human eye, too, can be adjusted just as in a camera. The pupil serves as the lens opening, which is widened or narrowed by the radial muscles which give the iris encircling the pupil its characteristic colour. As our eyes shift to the field we wish to focus upon, focal distance and pupil size are adjusted instantaneously and "fully automatically".

The structure of the retina (fig. 2), the photosensitive layer inside the eye, is complex. The optic nerve (together with the blood vessels) leads off from the back wall of the eye; there are no photosensitive cells at this point, which is known as the blind spot. The nerve fibres ramify and end in a succession of three different types of cell, which face away from the incoming light. Extensions leading from the third and innermost cell layer contain molecules which temporarily alter their structure as the light received is being processed, and which thereby emit an electrical impulse. The cells are called rods and cones after the shape of their extensions. The cones are colour-sensitive, whereas the rods are not; their photosensitivity, on the other hand, is far greater than that of the cones. One eye contains approximately one hundred million rods and six million cones, distributed unevenly across the retina. Exactly opposite the pupil lies the so-called yellow spot (fig. 3), which contains only cones in a particularly dense concentration. When we wish to see something in focus, we arrange for the image to fall on this yellow spot. There are many interconnections between the cells of the retina, and the electrical impulses from the one hundred million or so photosensitive cells are sent to the brain by just a million separate nerve fibres. The eye can thus be somewhat superficially described as a camera or television camera loaded with photosensitive film.

2 Cross-section of the retina

3 Eye with yellow spot

4 Kanizsa figure

From impulse to information

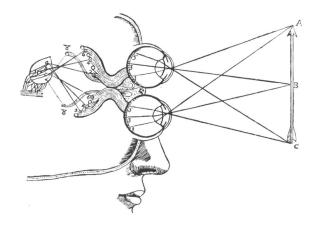

5 Illustration from Descartes' "Le traité de l'homme", 1664

But how do we actually see? Until recently, the question was barely addressed. The best anyone could do for an answer was merely the following: within the brain there is an area which specializes in vision; it is here that the retinal image is composed, albeit in brain cells. The more light that falls on a retinal cell, the more intense is the activity of its corresponding brain cell, so that the activity of the brain cells in our visual centre corresponds to the distribution of light upon the retina. In short, the process starts with an image on our retina and ends up with a matching picture on a small "screen" made up of brain cells. But this naturally still does not explain vision; it simply shifts the problem to a deeper level. For who is supposed to view this inner image? The situation is aptly illustrated in Figure 5, taken from Descartes' Le traité de l'homme. Here, all the nerve fibres end in the pituitary gland, which Descartes saw as the seat of the soul, and it is this which views the inner image. But the question still remains: how does this "viewing" actually proceed?

The notion of a mini-viewer inside the brain is not merely insufficient to explain vision, but ignores three activities which are manifestly performed by the visual system itself. Looking at a figure by Kanizsa (fig. 4), for example, we see a triangle with three circle segments at its corners. This triangle is not present on the retina, however; it is an invention of the visual system! It is almost impossible to look at Figure 6 without seeing a continuous succession of different circular patterns, all jostling for dominance; it is as if

we were directly experiencing inner visual activity. Many people find their visual system thrown into utter confusion by the Dallenbach figure (next page, fig. 8), as they seek to interpret its black and white patches in a meaningful way. (To spare you this torment, Figure 10 (p. 16) offers an interpretation which your visual system will accept once and for all.) By contrast, you will have no trouble in reconstructing the few strokes of ink of Figure 7 into two people in conversation.

An entirely different method of seeing is illustrated by the investigations carried out by Werner Reichardt from Tübingen, for example, who spent fourteen years studying the visual flight-control system of the housefly, for which he was awarded the Heineken Prize in 1985. Like many other insects, the fly has compound eyes composed

Figure 6

7. Brush drawing from the "Mustard Seed Garden Manual of Painting", 1679-1701

of many hundreds of individual rodlets and each forming its own photosensitive element. The flight-control system of the fly appears to be based on five independent sub-systems, or subroutines, which work rapidly (reacting approximately ten times faster than in humans) and efficiently. Its landing system, for example, operates as follows. When the fly's field of vision "explodes" (because a surface looms nearby), the fly banks towards its centre with a view to landing. If this centre lies above it, the fly automatically inverts to land upside down. As soon as its legs touch the surface, its "engine" is cut off. Once flying in a given direction, the fly extracts only two items of information from its field of vision: the point at which a moving patch of a specific size (which must match the size of a fly at a distance of 10 centimetres) is located within the visual field, and the direction and speed of this patch as it travels across the visual field. Processing of this data prompts automatic corrections to the flight path. It is extremely unlikely that the fly has a clear picture of the world around it. It sees neither surfaces nor objects; visual input is processed in such a way that the appropriate signals are transmitted directly to its motor system. Thus visual input is translated not into

an image of an image, but into a form which allows the fly to react to its environment in an adequate manner. The same can also be said of an infinitely more complex system, such as the human being.

There are a number of reasons why scientists have long been kept from addressing the fundamental question of how man sees. There seemed to be so many other visual phenomena to explain first: the complex structure of the retina, colour vision, contrast phenomena, afterimages, etc. Contrary to expectations, however, findings in these areas still failed to shed light on the primary problem. Even more significant was the lack of any new overall concept or framework within which visual phenomena could be ordered. The relative narrowness of the conventional field of enquiry can be deduced from an excellent manual on visual perception compiled by T.N. Cornsweet, based on his lectures for first- and second-term students. The author notes in his preface: "I seek to champion (in this book) what I hold to be the fundamental themes underlying the vast field which we loosely describe as visual perception." Examining the contents of his book, however, these "fundamental themes" turn out to be the effect of light on the cones and rods of the reti-

8 Dallenbach figure

na, colour vision, the way in which sensory cells can increase or reduce the extent of their mutual influence, the frequency of the electrical signals transmitted via the sensory cells and facial nerves, and so on. Research in this field is today following entirely new paths, as evidenced by the confusing diversity in the specialist press. Only the expert can form a

picture of the "new science of vision" currently emerging. There has been just one attempt to integrate some of its new ideas and findings into traditional thinking on visual perception in a manner accessible to the layman. Yet even here the questions "What is vision?" and "How do we see?" are not made the central focus of discussion.

From image to data-processing

It was David Marr, from the Artificial Intelligence Laboratory at the Massachusetts Institute of Technology, who made the first, admirable attempt to approach the subject from an entirely new angle in his book Vision, published posthumously. At a time which barely seemed ripe for such a discussion, he sought to address the core problem and propose possible solutions. Marr's findings are certainly not definitive and are today open to challenge on many points, but his book nevertheless has the advantages of logic and consistency. At all events, Marr's approach offers us a very useful background against which to plot the positions of impossible objects and ambiguous figures. We shall therefore attempt, in the following pages, to trace a broad outline of Marr's thought.

Marr described the shortcomings of conventional perception theory as follows:

"Trying to understand perception by studying only neurons is like trying to understand bird flight by studying only feathers: It just cannot be done. In order to understand bird flight, we have to understand aerodynamics; only then do the structure of feathers and the different shapes of birds' wings make sense." In this context, Marr names J.J. Gibson as one of the first to concern himself with meaningful questions of this kind in the field of vision. Gibson's important contribution, according to Marr, was to note "that the important thing about the senses is that they are channels for perception of the real world outside (. . .) He therefore asked the critically important question, How does one obtain constant perceptions in everyday life on the basis of continually changing sensations? This is exactly the right question, showing

that Gibson correctly regarded the problem of perception as that of recovering from sensory information 'valid' properties of the external world." And thus we reach the field of information processing.

It is not a question of Marr wishing to ignore other possible explanations of the phenomenon of vision. On the contrary, he expressly emphasizes that vision cannot be explained satisfactorily from one angle alone. Explanations have to be found for everyday experiences which agree with the findings of experimental psychology and the totality of the discoveries made by physiologists and neurologists concerning the anatomy of the nervous system. As regards information processing, the computer scientist would like to know just how such a visual system can be programmed and what the best algorithms are for the job. In short, he asks how vision can be programmed. Only a comprehensive theory can be accepted as a satisfactory explanation of the vision process.

9 The response of two different brain cells to optical stimuli with different directions on the retina.

Marr worked on the problem from 1973 to 1980. Unfortunately, he was unable to finish his work, but he laid the foundation stone for

further research into those areas which he was no longer in a position to explore for himself.

From neurology to the vision machine

The conviction that many human functions were controlled by the cerebral cortex was shared by neurologists from the early nineteenth century onwards. Opinions differed as to whether the individual functions were governed by a clearly-defined part of the cerebral cortex, or whether the brain in its entirety was involved in every function.

A now famous experiment by the French neurologist Pierre Paul Broca led to the general recognition of the specific-location theory. Broca was treating a patient who had been unable to speak for ten years, despite lacking none of his vocal chords. When the man died in 1861, an autopsy revealed that a part of the left side of his brain was deformed. For Broca, it was thus clear that speech was governed by this particular section of the cerebral cortex. His theory was confirmed by subsequent examinations of people suffering brain lesions, and it was eventually possible to map out the centres of the various vital functions on the human brain.

A century later, in the 1950s, D.H. Hubel and T.N. Wiesel began experimenting with the brains of living apes and cats. In the visual centre in the cerebral cortex they discovered nerve cells which are particularly sensitive to horizontal, vertical and diagonal lines in the

visual field (p. 15, fig. 9). Their sophisticated microsurgical techniques were subsequently adopted by other scientists.

The cerebral cortex thus houses not only the centres of various functions, but within such a centre, e.g. the visual centre, certain nerve cells which are only activated by the arrival of very specific signals. These are signals issuing from the retina which correlate to well-defined situations in the outside world. It was now assumed that information about various shapes and spatial arrangements lay openly accessible within the visual memory and that the information from the activated nerve cells was compared to this stored information.

This detector theory influenced the direction of research into visual perception in around 1960 - the same direction as that being pursued by scientists concerned with "artificial intelligence". The computerized simulation of the processes of human sight by a so-called "vision machine" was considered one easily attainable goal of such research. But things proved otherwise: it soon became clear that it was virtually impossible to write programmes which were capable of recognizing changing light intensities, shadow effects and surface structure, and of sorting the confusion of complex objects into meaningful patterns. Furthermore, such object recognition processes demanded an unlimited memory capacity, since images of infinite numbers of objects needed to be stored in countless different variations and lighting situations.

No further advances in the field of the visual recognition of a real environment appeared possible. Doubt began to arise whether computer hardware could ever hope to simulate the brain: when compared to the human cerebral cortex, in which each nerve cell has an average of 10,000 connections linking it to other nerve cells, the equivalent computer ratio of just 1:1 seems barely adequate!

10 Solution to the Dallenbach figure (p. 14)

Elizabeth Warrington's lecture

In 1973 Marr attended a lecture given by the British neurologist Elizabeth Warrington. She discussed how a large number of the patients she had examined with parietal lesions on the right side of their brain were perfectly able to recognize and describe a variety of objects, on condition that the objects were seen in their conventional form. Such patients could identify without difficulty a bucket seen side-on, for example, but were unable to recognize the same bucket seen end-on. Indeed, even when told they were looking down at a bucket from above, they vehemently refused to believe it! Even more surprising was the behaviour of those patients suffering lesions on the left side of the brain. Such patients often had no language and were therefore unable to name the object they saw or state its purpose. They were nevertheless able to convey that they correctly perceived its geometry, irrespective of the

angle from which they were seeing it. This prompted Marr to observe: "Warrington's talk suggested two things. First, the representation of the shape of an object is stored in a different place and is therefore a quite different kind of thing from the representation of its use and purpose. And second, vision alone can deliver an internal description of the shape of a viewed object, even when the object was not recognized in the conventional sense of understanding its use and purpose . . . Elizabeth Warrington had put her finger on what was somehow the quintessential fact of human vision – that it tells about shape and space and spatial arrangement." If this is indeed so, those scientists active in the field of visual perception and artificial intelligence (in as far as they are working on vision machines) will have to exchange the detector theory of Hubel's experiments for an entirely new set of tactics.

The module theory

A second of Marr's starting-points (and here, too, he looks back in part to Warrington's work) is his conviction that our sense of sight has a modular structure. In computer language, this means that our master programme "Vision" embraces a range of subroutines each of which is entirely independent of the rest and can also operate entirely independently of the rest. A clear example of one such subroutine or module is stereopsis, whereby depth is perceived as a result of each eye being offered a slightly different image. It was formerly generally held that, in order to be able to see in three dimensions, we first recognize viewed images as such and only subsequently decide whether the objects are near or far away. In 1960 Bela Julesz, who was also awarded the Heineken Prize in 1985, was able to demonstrate that spatial perception with two eyes derives solely from the processing of small differences between the two retinal images. It is thus possible to perceive depth even where absolutely no objects are present or even suggested. For his experiments, Julesz devised stereograms

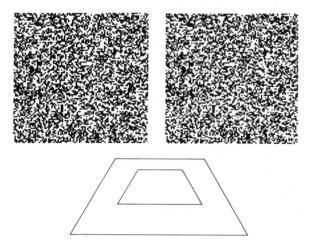

11 Random-dot stereogram by Bela Julesz, and the floating square

made up of randomly-distributed dots (cf. fig. 11). The image seen by the right eye is identical to that seen by the left in all but a central square region, which has been cut out, shifted a little to one side and stuck down again onto the background. The white gap left behind was then filled with a random pattern of dots. If the two images (in which no "representation" can be recognized) are viewed through a stereoscope, the square that was cut out appears to float in front of the

background. Such stereograms contain spatial data which are processed automatically by the visual system. Stereopsis is thus an

autonomous module contained within our vision. This module theory proved highly fruitful.

From the two-dimensional retinal image to the three-dimensional model

Vision is a multi-stage process which transforms two-dimensional representations of the outside world (retinal images) into useful information for the viewer. It starts from a two-dimensional retinal image, which – ignoring colour vision for the time being – records only degrees of light intensity. As the first stage, involving just one module, these

one but several different modules. Marr coins the rather unwieldy notion of "2½-dimensional" in order to emphasize that we are dealing with spatial information from the angle of the viewer: a 2½-D sketch is thus a representation which still suffers from perspective distortions and which cannot yet be directly compared to actual spatial arrange-

12 During the visual process, the retinal image (left) is translated into a primal sketch in which intensity changes become apparent (right).

degrees of intensity are translated into intensity changes – in other words, into contours, which indicate sudden alterations in light intensity. Marr states precisely which algorithm is thereby involved (expressed mathematically, incidentally, the transformation is a fairly complex one), and how the perception and nerve cells are able to perform this algorithm. The result of this first stage is what Marr calls a "primal sketch", which offers a summary of intensity changes, their mutual relationship, and their distribution across the visual field (fig. 12). This is a significant step, since in the visible world intensity changes frequently correspond to the natural contours of objects. The second stage leads to what Marr calls a "21/2-D sketch". The $2\frac{1}{2}$ -D sketch maps the orientation and depth of visible surfaces around the viewer, thereby drawing upon information from not

ments. The drawing of a $2^{1}/_{2}$ -D sketch shown here (fig. 13) simply illustrates for our purposes some of the different pieces of information processed in such a sketch; no image of this kind is actually produced inside our brain, however.

So far the visual system has been operating, via a number of modules, autonomously, automatically and independently of data on the outside world stored in the brain. During the final stage of the process, however, it is possible that reference is made to existing information. This last stage delivers a 3-D model: a stable description independent of the angle of the viewer and directly suitable for comparison with the visual information stored in the brain.

According to Marr, the component axes of a shape play a major role in the constitution of the 3-D model. Those to whom this notion is

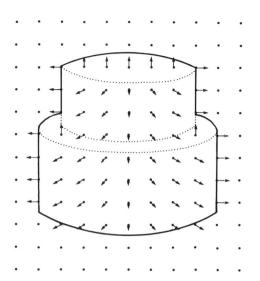

13 Drawing of a 2¹/₂-D sketch – "a viewer-centred representation of the depth and orientation of visible surfaces" (Marr).

unfamiliar may find it a little far-fetched, but there is indeed some evidence which seems to support it. First, many objects from our environment (in particular animals and plants) can be portrayed quite effectively in simple pipe-cleaner models. The fact that we are still able to recognize them lies in our identification of the reproduction of their natural axes (fig. 14).

Secondly, this theory offers a plausible explanation for the fact that we are able to visually dismantle an object into its various parts. This faculty is reflected in our language, which gives different names to each part. Thus, in describing the human body, designations such as "body", "arm" and "finger" indicate a differentiation according to component axes (cf. fig. 15).

The theory thirdly accords with our ability to generalize and at the same time differentiate between shapes. We generalize by grouping together objects with the same main axes, whereas we differentiate by analyzing their subsidiary axes, such as the boughs of a tree. Marr gives the algorithms with which the 3-D model is calculated from the $2^{1}/2$ -D model; this, too, is a largely autonomous process. Marr himself notes that these algorithms only work where clear axes are present. In the case of a crumpled piece of paper, for example, possible axes may be hard to identify, and will offer an algorithm almost no point of application.

The link between the 3-D model and the

visual images stored in the brain only becomes active in the process of the recognition of an object.

It is here that a large gap still yawns in our knowledge. How are these visual images stored? How does the recognition process unfold? How does the comparison between existing images and the 3-D image currently being composed actually proceed? This last point is touched upon by Marr (cf. fig. 16), but a great deal of scientific ground will have to be covered before any more clarity or certainty is gained.

Although we ourselves are unconscious of the various phases in which visual information is processed, a number of clearly-demonstrable parallels exist between these phases and the different ways in which, over the course of history, we have rendered our impressions of space on a two-dimensional surface.

Thus the Pointillists emphasize the contourless retinal image, while line drawings correspond to the stage of the primal sketch. A Cubist painting might be compared to the processing of visual data in preparation for the final 3-D model, although this was undoubtedly not the intention of the original artist.

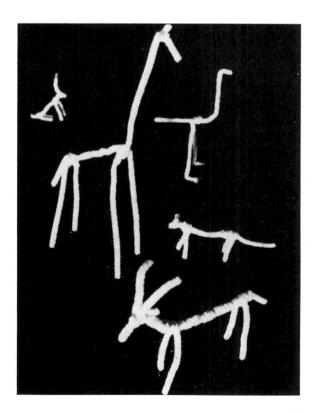

14 Simple animal models can be identified from their component axes.

Man and computer

In his comprehensive approach to the subject, Marr sought to show how we can understand the process of vision without having to call upon knowledge which is already available in the brain.

He thereby opened up a new avenue for researchers of visual perception. His ideas can be used to steer a more efficient course towards the realization of a vision machine.

When Marr was writing his book, he must have been aware of the effort which his readers would be required to exert if they were to follow his new ideas and their implications. This can be sensed throughout the

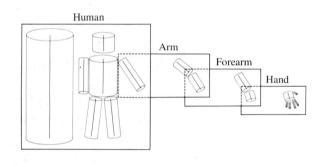

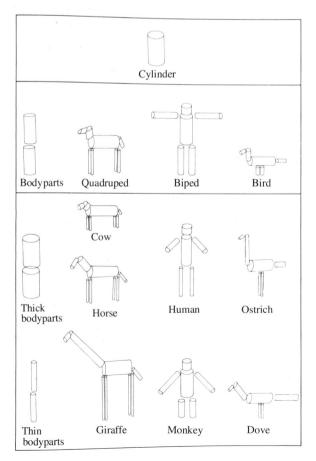

work and surfaces most forcibly in the last chapter, "In Defense of the Approach". It is a polemic "justification" lasting a good 25 pages in which he seizes one last opportunity to argue his cause. In this chapter he holds a conversation with an imaginary sceptic, who attacks Marr with arguments such as the following:

"I'm still unhappy about this tying-together process and the idea that from all that wealth of detail all you have left is a description. It sounds too cerebral somehow . . . As we move closer to saying the brain is a computer, I must say I do get more and more fearful about the meaning of human values."

Marr offers an intriguing reply: "Well, to say the brain is a computer is correct but misleading. It's really a highly specialized information-processing device – or rather, a whole lot of them. Viewing our brains as information-processing devices is not demeaning and does not negate human values. If anything, it tends to support them and may in the end help us to understand what from an information-processing view human values actually are, why they have selective value, and how they are knitted into the capacity for social mores and organization with which our genes have endowed us."

15 The model axis (left) breaks down into component axes (right).

16 New shape descriptions are related to stored shapes in a comparison which moves from the general (above) to the particular (below).

3 Ambiguous figures

The exterior world conveys itself to the human individual largely via the sense of sight, which comprises the eyes, the optic nerves, and the visual centre in the brain. For the sake of brevity, in the following chapters we shall refer to the sense of sight simply as the EYE. (Where eye appears in the usual, lower case, only the optical instrument is intended.)

As discussed in the preceding chapter, the vision process begins with a picture of the environment projected onto the retina via the lens. The information on the retina is highly complex. For our purposes, two categories may be distinguished: image information, based on *pictographic* elements which reproduce the objects present, and spatial information, composed of *stereographic* elements which reproduce the spatial relationships between these objects.

These two types of element generally appear together, as a simple example will illustrate. In the drawing of two fishermen on the banks of a canal (fig. 1), the *pictographic* elements show us two human figures and a ditch or trench. The *stereographic* elements tell us the following: one figure is bigger than the other and partially obscures it; the figures are part dark, part light; two shadows fall behind the dark parts; the borders of the canal converge.

The EYE processes both the pictographic and the stereographic elements into one meaningful interpretation. In our normal environment this usually poses no difficulties, and the entire process takes place within a fraction of a second. But occasionally there is a hiccup and the process comes to a stand-

still; only then do we become conscious of the functioning of our EYE.

Perhaps you have also experienced an incident similar to one that occurred to me. Lying in bed one day, looking at the objects on my bedside table, I noticed something which struck me as completely foreign: a small frame with a metallic gleam on its left side only. I knew for a fact that I possessed no such frame, so one couldn't be standing there. I didn't move, but continued to look at it patiently, hoping to penetrate the mystery. Suddenly I recognized my lighter on the left, standing upright, and on the right a glass, partially obscured by a postcard. This made a lot more sense, and I subsequently found it quite hard to recreate in my mind's eye my original impression of a frame.

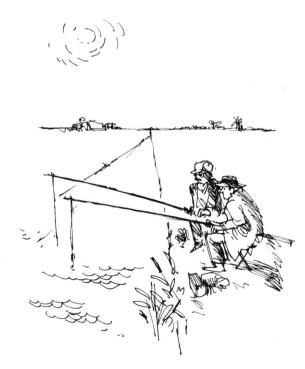

Figure 1

There are other instances when the EYE offers us two (and in some cases even more) equally valid interpretations of a particular object configuration. It should be noted, however, that such interpretations derive not from our own mental reflection upon what we are seeing, but directly from the EYE itself. We become aware of an ambiguity because we see first one interpretation, then another, and then, a few seconds later, the first again, and so on. We are dealing here with a process which we ourselves can neither control nor stop, since it takes place automatic-

ally. In such cases we speak of ambiguous retinal images and – where these are triggered by a pictorial figure – of ambiguous figures. Their ambiguity can be *pictographic* or *stereographic* in nature. Although this book is primarily concerned with stereographic (spatial) ambiguities, I would not wish to deprive the reader of some of the particularly entertaining ambiguities which can arise in the pictographic field. For this reason, and to help clarify the distinction between the two fields, I have included a number of examples below.

Pictographic ambiguity

Almost everyone will have come across the phenomenon of pictographic ambiguity, especially in the form of "Freudian" pictures. A particularly good example is My wife and my mother-in-law (fig. 2), published in 1915 by the cartoonist W.E. Hill, which offers a finely-balanced choice of interpretations by omitting all extraneous details. See whom you recognize first – it can be a hard task even for psychologists! A few years later, Jack Botwinick produced a pendant picture, My husband and my father-in-law (fig. 3). Many such images have been invented over the years; the Eskimo-Indian (fig. 4) and Duck-Rabbit (fig. 5) are particularly wellknown.

There are also ambiguous figures whose interpretation depends upon the angle from which they are seen. An extreme example in this case is the comic strip series by Gustave Verbeek which appeared in the *New York Herald* from 1903 to 1905.

Each instalment must first be read and viewed normally, and then the whole thing turned upside down. Figure 6 shows Little Lady Lovekins being picked up by Rock, the giant bird; viewed upside down, the picture shows a large fish upsetting old man Muffaroo's canoe with its tail. Famous, too, are the "double images" in which the significance and function of object and background continuously alternate. In a first glance at Sandro del Prete's *The window opposite* (fig. 7), you will probably see no more than a vase of flowers, a wine glass, and a pair of stockings hanging out to dry.

2 W.E. Hill, "My wife and my mother-in-law"

Stereographic ambiguity

The images on our retina are two-dimensional. An important function of the EYE is to reconstruct three-dimensional reality from these two-dimensional images.

When we look through two eyes, the two images which fall upon our retina contain slight differences; an independent EYE programme uses these differences to calculate – with a high degree of accuracy up to a distance of fifty metres – the spatial relationships between objects and ourselves, which suggests to us a direct impression of space. But even the retinal image of one eye alone contains

sufficient data with which to produce a reliable picture of three-dimensional reality. The reduction of three-dimensionality to two-dimensionality involves a fundamental ambiguity, however, as can be illustrated in a simple example. The line AB in Fig. 8a (p. 24) can be interpreted by the EYE in a number of ways. It can be seen, e.g., as a line of ink on the page of this book, or as a straight line in space, whereby we cannot tell whether A or B is nearer. As soon as we provide the EYE with a little more information, e.g. by incorporating the straight line AB into

the drawing of a cube, the positions of A and B in space are established. In Fig. 8b, A appears nearer than B, and B lower than A; in Fig. 8c these relationships are reversed. In Fig. 8d the same straight line AB runs horizontally from the foreground way back to the horizon!

A cube in which the twelve edges alone are drawn as lines (p. 24, fig. 9) is called a Necker cube after L.A. Necker, the German professor of mineralogy, the first person to study stereographic ambiguity from the scientific perspective.

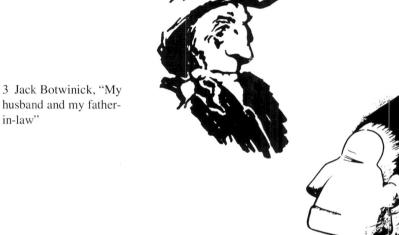

5 Duck-Rabbit

4 Eskimo-Indian

6 Gustave Verbeek, cartoon from his Upsidedown series

in-law"

7 Sandro del Prete, "The window opposite", pencil drawing

The Necker cube

On 24 May 1832 Professor Necker wrote a letter to Sir David Brewster, whom he had recently visited in London. The second half of the letter was devoted to what has since become famous as the Necker cube. The letter is important not just because it was the first time that a man of science had described the phenomenon of optical inversion, but also because it captures something of the astonishment of its author. It also sheds light on a typical feature of scientific practice of the times, whereby it was not yet common to work with a number of different test participants, nor to employ specially-built apparatus. Rather, the researcher made his own observations and attempted, often with very basic means, to see beyond appearances, in the hope of arriving at a conclusion within the framework of his own knowledge.

"In the case of the object to which I would like to draw your attention, we are dealing with a perceptual phenomenon in the field of

optics, a phenomenon which I have observed many times when studying pictures of crystalline shapes. I am referring here to a sudden and involuntary change in the apparent position of a crystal or other three-dimensional body reproduced on a two-dimensional surface. What I mean can be more simply explained with the help of the attached illustrations. The rhombus AX is drawn in such a way that A is nearest to the viewer and X furthest away. ACBD thus represents the frontal plane, with XDC a lateral plane behind it. If you study this figure for a while, however, you will observe that the apparent position of the rhombus sometimes changes, whereby X appears to be nearest and A furthest away and plane ACBD moves behind plane XDC, giving the whole body an entirely different orientation.

For a long time I remained uncertain as to the explanation of this random and involuntary change, which I regularly encountered in various forms in books on crystallography. The only thing I was able to detect was an unusual sensation in the eye at the moment of change. To me this indicated an optical effect, and not just (as I had first thought) a mental one. Later, after thorough analysis, it seemed to me that the phenomenon was linked to the focal setting of the eye. When the point of focus on the retina (i.e. the yellow spot) is directed at A, for example, this corner is seen in sharper focus than the others. This naturally implies its being nearer and at the front, while other corners seen less clearly give the impression of lying further back.

The 'switch' occurred when the point of focus was shifted to X. Once I had discovered this solution, I was able to find three separate proofs of its correctness. First, I was able to see the object in the orientation of my choice, an orientation which I could change at will simply by shifting my focus between points A and X.

Secondly, when I concentrated on A and saw the rhombus in the correct position with A in the foreground, and then, without moving my eyes or the figure, slowly moved a concave lens between my eye and the figure from the bottom of the figure to the top, the switch took place as soon as the figure be-

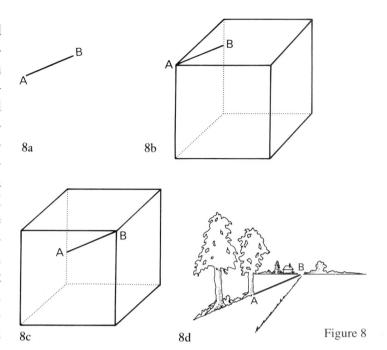

came visible through the lens. It thereby assumed the orientation in which X appeared furthest to the front. And that solely because X had replaced A at the point of focus, without any spatial adjustment of the latter.

Finally, when I looked at the figure through a hole, punched in a card with a needle, in such a way that either A or X could not be seen, the orientation of the body was determined by the corner that was visible, whereby this corner was always the nearest. It is then impossible to see it in any other way, and thus no switch takes place.

What I have said of the corners is also true of the sides: the planes to which the line of sight or the yellow spot of the retina are directed are always seen as lying in the foreground. It is thus clear to me that this small and at first sight so puzzling phenomenon is based on the law of focus.

You will no doubt be able to draw many conclusions from the observations described here which I, in my ignorance, am unable to predict. You may use these observations according to your own discretion."

Many who have made the same experiment since Necker have come to the conclusion that this switching occurs spontaneously and independently of the point of focus. Nevertheless, Necker's original assumption – that the phenomenon occurs in conjunction with the processing of the retinal image in the brain – was correct. In the Necker cube, the

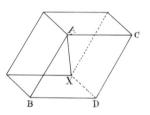

9 A Necker parallelepiped

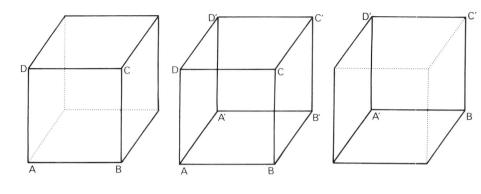

Figure 10

EYE cannot determine whether one point (or plane) is closer or further away than another. Figure 10 shows the Necker cube, with its solid ABCD-A'B'C'D' lines, between two others illustrating its two possible interpretations. When we look at the Necker cube, we see first the figure in the centre, then the one on the right, followed shortly afterwards by the one on the left – and so on. This switching from "A-is-nearer-than-A" to "A-is-further-away-than-A" we call perceptual inversion: the cube in the centre is thus the inverse representation of the cube on the right, and vice versa.

However, this alternation in the relative distances of ABCD and A'B'C'D' to the viewer is not what strikes us most forcibly. Most conspicuous of all is the fact that both cubes have quite different orientations, just as Necker emphasized in his letter. Thus AD and A'D' appear to intersect, although in the drawing they in fact lie parallel. We might describe the phenomenon of perceptual inversion more precisely as follows: all lines have the same orientation in the retinal image, but as soon as the interpretation switches to the inverse figure, all lines (in space) appear to change their orientation. Such changes of orientation can prove highly surprising, as we shall see. Perceptual inversion in the upper pair of dice in Figure 11 has

based on two photographs of the same configuration of dice, but taken from different angles. The left-hand die was placed against a wall, and squares of the same size as its sides were marked out on the wall and ground. The lower drawing makes the completely different orientations of the dice more than clear.

The angle at which a cube is shown also determines the angle through which its sides will project after inversion. In the left-hand pair of dice in Figure 12, this angle is only small; in the right-hand pair (corresponding to the upper drawing in Figure 11), it reaches a maximum.

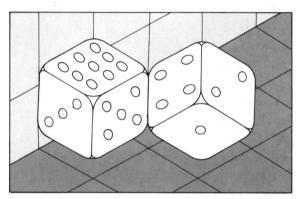

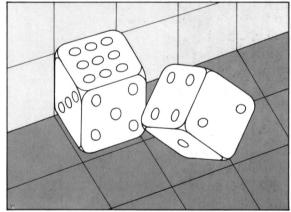

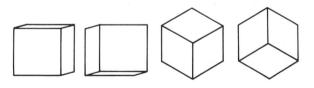

Figure 11

Figure 12

Concave and convex

Although the Necker cube suggests two different geometric forms, the terms "concave" and "convex" can be applied to neither; we

been encouraged by the choice of angle at which the dice are shown. The drawings were

> can always see both the inside and the outside of the cube at once. The situation changes when we omit from our drawing three planes

13 Monika Buch, "Intersecting bars", acrylic on fibreboard, 60 x 60 cm, 1983. The impression of intersecting bars is reinforced here by the fact that the bars appear grouped at a slight angle to each other within the pictorial plane. The tautness of the composition is emphasized by the regular arrangement of the twenty-four small rhombic planes forming the ends of the bars.

which meet at or near the centre of the cube, as in dice reproduced above. We now obtain a figure which again suggests two inverse spatial bodies, but of a different nature: one convex, in which we see only the *outside* of the cube, and one concave, whereby we perceive only three of the planes *inside* the cube. Most people recognize the convex form immediately, but have difficulty seeing the concave form unless suitable subsidiary lines are added.

In his lithograph *Concave and convex* (fig. 14), Maurits Escher demonstrated how the viewer can be forced, by specific geometrical means, to interpret the left half of a picture as convex and the right half as concave; the transition between the two halves is thereby particularly interesting. At first sight, the building appears symmetrical: the left

half is more or less the mirror image of the right, and the transition in the middle is not abrupt, but gradual and natural. And yet, as we cross the centre, we find ourselves plunging into something even worse than a bottomless abyss: everything is quite literally turned inside out. Upper side becomes underside, front becomes back. Alone in resisting this inversion are the human figures, lizards and flowerpots; these we continue to identify with palpable realities which are unknown to us in "inside-out" form. Yet they, too, must pay the toll for crossing over onto the other side: they must inhabit a world in which their topsy-turvy relationship to their surroundings is enough to make the viewer dizzy. Take the man climbing the ladder in the bottom left-hand corner: he is about to reach a landing in front of a small temple. He may

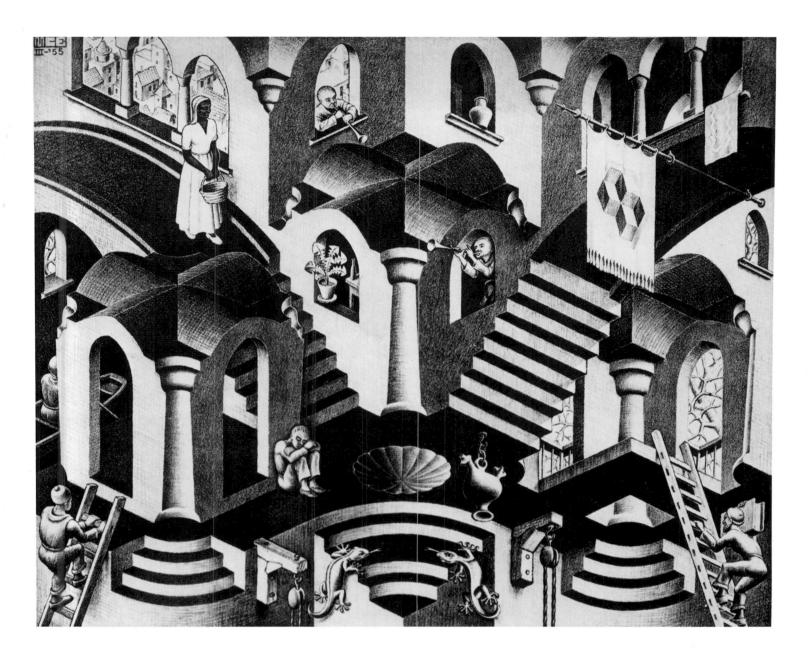

14 M.C. Escher, "Concave and convex", lithograph, 27.5 x 33.5 cm, 1955. "Can you imagine, I spent more than a whole month brooding over this picture constantly, because my initial drafts were all far too difficult to make head or tail of." (M.C. Escher)

wonder why the scalloped basin in the centre is empty. Then he might try to mount the steps on the right. And now the dilemma is upon him: what he took to be a flight of stairs is in fact the underside of an arch. He will suddenly find that the landing, once solid ground beneath his feet, has become a ceiling, to which he is strangely glued in defiance of all the laws of gravity. The woman with the basket will find the same happening to her if she descends the stairs and crosses the centre. If she stays on the left-hand side of the picture, however, she will be safe.

Most visually discomforting of all, perhaps, are the two trumpet-players located one on each side of the vertical centre line. The upper, left-hand player is looking out of a window over the groin-vaulted roof of a small temple. From his position he could

feasibly climb out (or in?), drop onto the roof and jump down onto the landing. Any music played by the trumpeter lower down on the right, on the other hand, will float up to a vault above his head. This player had better dismiss any thoughts of climbing out of his window, for below him is nothing but a void. In his half of the picture, the "landing" has been inverted and lies out of sight beneath him. The emblem on the banner in the top right-hand corner of the picture neatly summarizes the content of the composition.

In allowing our eye to travel slowly from the left of the picture to the right, it is also possible to see the right-hand vault as a flight of steps – in which case the banner appears totally implausible . . . But let me leave you to explore for yourself the many other confounding dimensions of this intriguing print!

Common inversion illusions

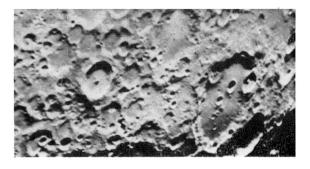

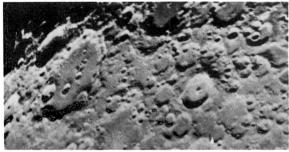

15 Photograph of the moon (left) and the same photograph printed upside down (right).

We frequently experience geometric ambiguity in our retinal images even where this is not intended by the original picture viewed. Studying a photograph of the moon, for example, we find after a while that the craters

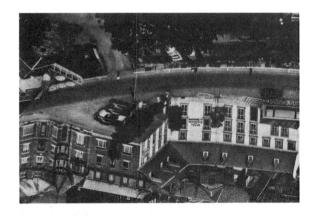

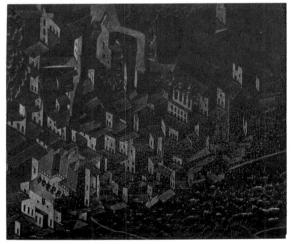

transform themselves into raised hillocks, despite the fact that we know them to be craters. In nature, whether an image is interpreted as "concave" or "convex" is strongly influenced by the fall of the light. Where the light comes from the left, the left-hand crater wall will have a bright exterior and a dark interior.

If we study a photograph of the moon, we assume a certain angle of light in order to recognize its craters as such. If, next to this first moon photograph, we then place the same photograph turned upside down (fig. 15), the light conditions assumed in the first will be applied to our reading of the second, whereby it is very difficult to resist an "inverted" interpretation: almost all the crater depressions in the first photograph are now read as hilly elevations in the second. The same phenomenon can sometimes be ob-

served simply by turning a drawing or a normal photograph upside down. This is illustrated here in the examples of a postcard of a Belgian village (fig. 16) and a detail from a picture by Escher (fig. 17), both printed upside down here.

Even utterly normal everyday objects can suddenly assume an ambiguous dimension, particularly when we see them in silhouette or almost in silhouette.

16 Postcard of a Belgian village, printed upside down.

17 Detail from M.C. Escher's "Town in southern Italy", 1929, printed upside down.

Mach's illusory movements

A phenomenon can be observed when looking at a three-dimensional reality which does not occur in the case of two-dimensional reproductions. This can be demonstrated by means of a simple and entertaining experiment. Take a rectangular piece of paper

measuring approximately 7 x 4 cm and fold it in half lengthways. Then open it out again into a V-shape (fig. 18), and stand it upright with the fold pointing away from you. Now look at it with just *one* eye. After a few seconds, the vertical paper inverts into the form

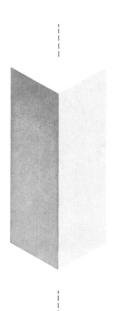

Figure 18

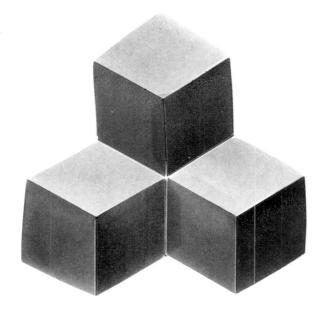

19 Paolo Barreto's Holocube

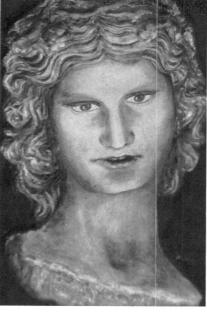

21 Two photographs of a concave picture by Sandro del Prete. The EYE nevertheless prefers a convex interpretation.

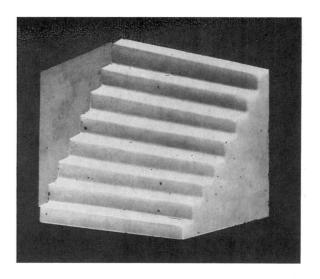

20 Photograph of the small sheet-metal staircase given to M.C. Escher by Prof. Schouten. This model was the inspiration behind Escher's lithograph "Concave and convex". In drawing form it has long been known as Schröder's steps.

of a long, horizontal roof. If you now turn your head to the left, to the right, up, and down, you will observe the "roof" appearing to pivot against the background. Two things are striking: first, this pivoting movement occurs contrary to our expectations; secondly, the inverse form remains stable as long as the movement continues. (The experiment can naturally also be made with the paper placed horizontally with the fold pointing upwards; the inverse form is then vertical.)

We can devise many models to demonstrate this illusory movement. Paolo Barreto thought up a simple but highly effective inversion model in his Holocube (fig. 19), a composition of three concave cubes. The figure's inverse (convex) form is, however, much more stable than its actual concave geometric form; viewed at some distance, therefore, it appears as three convex cubes which, if we turn our head, seem to float strangely in space. This phenomenon, first described by Ernst Mach, also occurs spontaneously in concave images. We see such images as convex because the concave form strikes us as improbable (figs. 20 and 21). When we move, the inverse image follows us. This is particularly surprising when the image in question is the cast of another face!

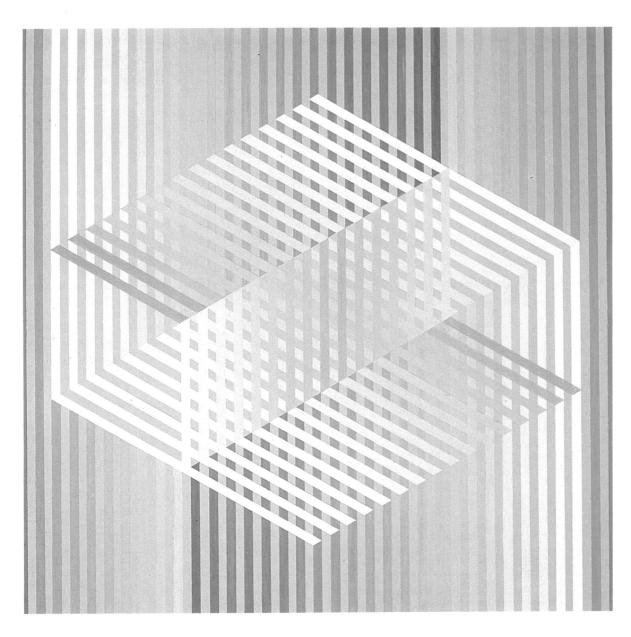

22 Monika Buch, "Thiéry's figure II', acrylic on fibreboard, 60 x 60 cm, 1983. The vertical strips composing the picture are extended to fill the entire surface.

Pseudoscopy

In connection with his picture Concave and convex, Escher confided to me that although he was able to see many objects inverted with one eye, he had never managed to do so with a cat. During this same period I introduced him to the phenomenon of pseudoscopy, in which this kind of "inside-out" vision is forced upon the EYE. We can make our program for three-dimensional vision run the wrong way round by offering the left eye an image destined for the right eye, and vice versa. The same effect can be achieved. somewhat more simply, with the use of two prisms showing both eyes a mirror image. Escher was most enthusiastic about these prisms; for a long time he carried them about with him everywhere, in order to view threedimensional objects of all kinds in their pseudoscopic form. As he wrote to me: "Your prisms are basically a simple means of experiencing the same sort of inversion that I was trying to achieve in my picture Concave and convex. The small, white, sheet-metal staircase given to me by the mathematician Professor Schouten, and which gave rise to the picture Concave and convex, inverts as soon as you look at it through the prisms. I have mounted them between two pieces of cardboard, held together with elastic bands. They make a handy pair of 'binoculars'. I took them on a walk with me and entertained myself e.g. by looking at some leaves which

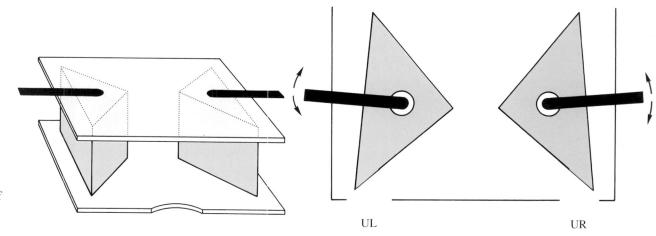

23 and 24 Perspective drawing and top view of a prism pseudoscope

had fallen into a pond, and which I could suddenly turn on their heads: a 'water level' with water on top and air below, without a drop falling 'down'! The normal interchange of left and right is interesting, too. If you watch your feet moving, and try to extend your right one, it is the left foot which appears to move."

With a little care and patience, you can use Figures 23 and 24 to build your own pseudoscope, allowing you to experience illusory movements on a larger scale.

Thiéry's figure

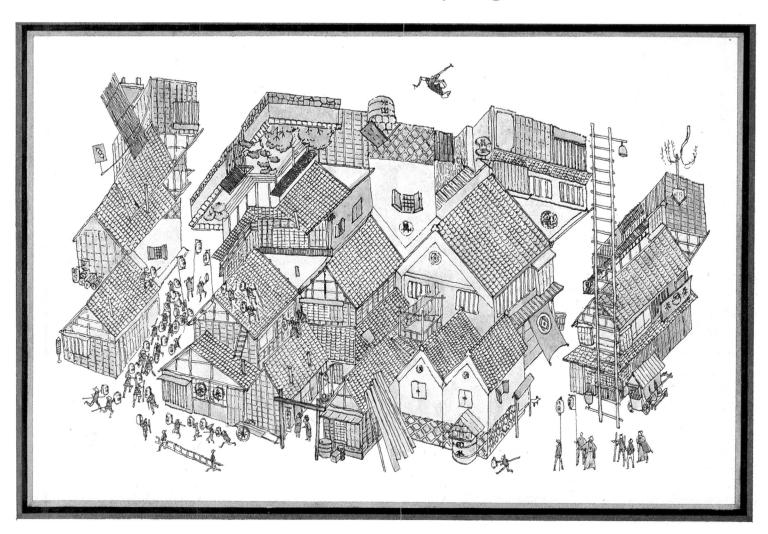

25 Invertible illustration by Mitsumasa Anno. Several houses share a common roof and represent a variant of Thiéry's figure.

In 1895 Armand Thiéry published a detailed article on his investigations into a specific area of optical illusions. It is here that we find the first mention of the figure that now bears his name, and which has since been employed in countless variations by the artists of Op Art. The most famous such variant consists of five rhombuses with angles of 60 and 120 degrees (fig. 26). This appears to most people as a highly ambiguous figure, in which two cubes continuously and alternately assert either their concave or convex form. Thiéry was careful to conduct all his experiments under the same conditions and employed several test participants "in order to make the observations more reliable". He still fell short of the methods of modern statistics, however, since he failed to specify the arithmetical mean of his observation results, and furthermore chose his test participants for their specialist knowledge in related fields, such as experimental psychology, applied drawing, aesthetics etc. - precisely what a modern-day researcher would avoid! Thiéry writes: "All perspective drawings reflect a specific position adopted by the eye of the artist and the viewer. Depending on the extent to which we clarify this position, different drawings can be variously interpreted. Figure (27) is an illustration of a prism seen from below, Figure (28) a prism seen from above. But these drawings become ambiguous when the two figures are combined so that the two prisms share a common face (fig. 29). When read from right to left, the figure represents a folding screen seen from above."

Strangely, Thiéry does not mention the second interpretation, but emphasizes that the figure bears similarities to Schröder's steps (a drawing of the same steps which Prof. Schouten gave to Escher), and observes: "Here too, therefore, there exist two possible interpretations." He goes on to conclude that we may see the figure both as the prism of Figure 27 and as the prism of Figure 28, each with an extension.

It is a less well-known fact that the symmetrical Thiéry figure (fig. 26) can also be perceived as an entirely unambiguous figure. Professor J.B. Deregowski once brought me a wooden block having precisely such a form. For those who have seen such an object, Thiéry's figure ceases to be ambiguous. If you trace the figure's "construction plan" (fig. 30) onto another piece of paper, cut it out and make it up, you will see immediately how it works. Viewing your paper model from above, you will see the Thiéry figure; it will then be difficult for you ever again to see it as ambiguous. The EYE prefers simple solutions!

When presented with geometrically ambiguous figures, the EYE spontaneously and alternately offers us two spatial solutions. Something is either concave or convex; we are either looking up at the underside or down onto the top of a surface . . . The obvious question here is whether it is possible to confront the EYE with a situation in which this alternate "either/or" becomes a simultaneous "both/and". This would produce an impossible object, since two interpretations cannot both be correct at the same time. In Chapter 4 we shall be meeting figures in which this extraordinary situation indeed arises.

26 Thiéry's figure

30 "Construction plan" of Thiéry's figure

Figures 27, 28, 29

4 Impossible objects

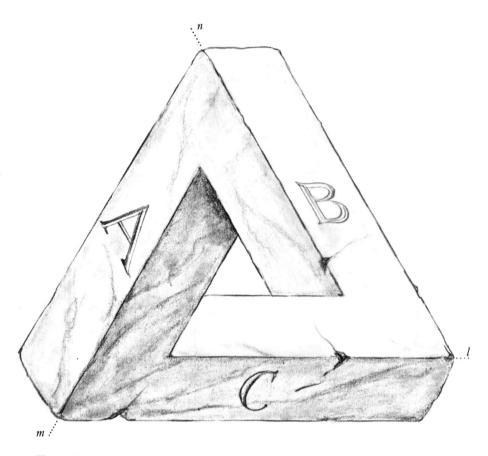

Figure 1

This is an impossible tri-bar. It is not the illustration of a spatial object, for such an object cannot exist. Yet our EYE accepts both this fact and the object without further ado. We may subsequently come up with a variety of logical arguments – how C, for example, lies in a horizontal plane, while A moves towards us and B away from us, and how, if A and B are constantly moving away from each other, they cannot possibly meet at the top as they apparently do. We might point out that the tri-bar forms a closed triangle, all three sides are perpendicular to each other, and the sum of their internal angles thus totals 270 degrees – which is impossible. As a third line of attack, we might enlist the aid of a principle of stereometry, namely that three nonparallel planes always meet at a single point. In Figure 1, however, we see that:

dark-grey plane C meets white plane B;
 the line of intersection is l;

- dark-grey plane C meets light-grey plane
 A; the line of intersection is m;
- white plane B meets light-grey plane A; the line of intersection is *n*;
- lines of intersection l, m and n intersect at three different points.

The figure in question thus demonstrably fails to satisfy the stereometric stipulation that three non-parallel planes (here A, B and C) should meet at a single point.

To recap: however simple or complex our subsequent reasoning, the EYE signals such internal contradictions without the slightest explanation.

The impossible tri-bar is paradoxical in several respects. The eye takes no more than a split second to transmit the message: "This is a closed object composed of three bars." This is followed a moment later by: "This object cannot in fact exist . . . " The third message might read: "... and so the first impression was incorrect." In theory the figure should dissolve into a set of lines bearing no meaningful relationship to each other and no longer organized into the shape of a tri-bar. But this does not happen; instead, the EYE signals afresh: "It is an object, a tri-bar." In short, the conclusion is that it is an object and it is not an object – and herein lies the first paradox. Both interpretations are argued with equal conviction, as if the EYE were leaving the final verdict to some higher authority.

A second paradoxical feature of the impossible tri-bar emerges from the reasoning surrounding its construction. If bar A moves towards us and bar B moves away from us, yet they still meet, the corner that they form must lie in two places at once, one near the viewer and one further away. (The same naturally applies to the other two corners, since the object remains identical in shape even if we turn it so that a different corner is pointing upwards.)

2 Bruno Ernst, photograph of an impossible tri-bar, 1985

3 Gerard Traarbach, "Perfect timing", oil on canvas, 100 x 140 cm, 1985, printed in reverse

4 Dirk Huizer, "Cube", irisated screenprint, 48 x 48 cm, 1984

The reality of impossible objects

One of the most perplexing questions asked of impossible objects concerns their reality: do they exist or not? The drawing of the tribar naturally exists; of that there can be no doubt. At the same time, however, there can also be no doubt that the three-dimensional form presented to us by the EYE does not exist as such in the outside world. For this reason we have chosen to speak of impossible *objects* rather than impossible *figures* (as they have more commonly become known in the English language). This would seem a satisfactory means of resolving the dilemma. And yet when we examine, for example, the impossible tri-bar

more closely, its spatial reality continues to force itself upon us.

Confronted by the individual parts in disassembled form (fig. 6), it is almost impossible not to believe that simply bolting together the bars and cubes will produce the desired tribar.

Figure 3 will have a special appeal for crystallographers. The object appears to be slowly growing; the cubes slot themselves into the existing crystalline grid, and there is no irregularity.

The photograph (fig. 2) is real, although the tri-bar – an arrangement of cigar boxes photographed from a certain angle – is not. It

is a visual joke which I devised for Roger Penrose, co-author of the first article on the impossible tri-bar (cf. p. 72).

Figure 5 shows a tri-bar made up of numbered blocks measuring 1 x 1 x 1 dm. Simply by counting the blocks, we can work out that the figure has a volume of 12 dm³ and a surface area of 48 dm².

In a similar way, we can calculate the distance travelled by e.g. a ladybird walking its way round the tri-bar (fig. 7). The mid-point of each bar is numbered and the direction of travel is indicated by arrows. The surface of the tri-bar thereby appears to consist of a long, uninterrupted track; the ladybird must complete four circuits before arriving back at its starting-point.

You might be starting to suspect the impossible tri-bar of harbouring some "secret" on its invisible side. But a transparent view of the impossible tri-bar can be drawn without difficulty (fig. 8). Here, all four neighbouring side planes are visible. The object thereby loses none of its reality.

Let us pose the question once more: what reality does the impossible tri-bar, which can be interpreted and manipulated in so many ways, ultimately have? We should remember that the EYE processes the retinal image of an impossible object just as it would the retinal image of a chair or a house. The result is a "spatial image". In this stage there is no difference between an impossible tri-bar and an ordinary chair. The impossible tri-bar thus exists in the depths of our brain, and indeed at exactly the same level as all the other objects we see surrounding us. The EYE's refusal to affirm its three-dimensional viability in the outside world in no way lessens the fact of the presence of the impossible tri-bar inside our head.

In Chapter 1 we met a type of impossible object whose substance appeared to vanish into nothing. In his pencil drawing of a *Passenger train* (p. 38, fig. 11), Fons de Vogelaere subtly works this same type into the reinforced corner pillar at the left of the picture. If we follow the pillar down from top to bottom or cover the lower section of the picture up to the tracks, we see a pillar supported by four buttresses (of which only two are visible). Seen from below, however, the same pillar

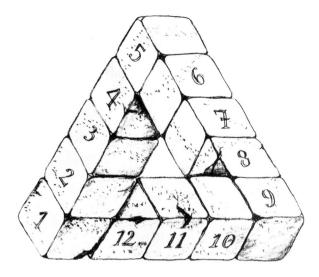

Figure 5

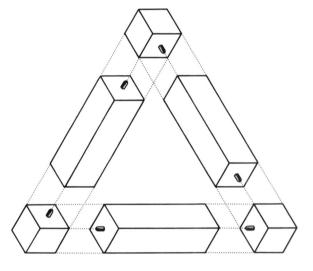

Figure 6

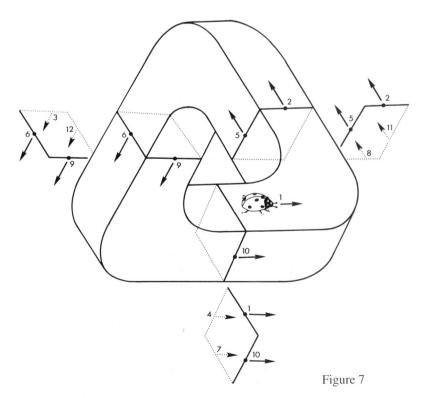

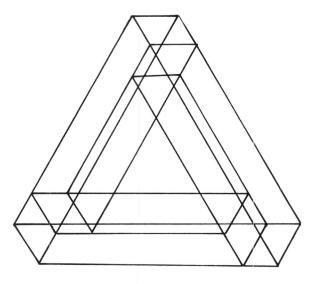

Figure 8

reveals a relatively wide gap through which the train can pass. Solid blocks of stone are thus simultaneously...thin air!

This type of object is easy enough to categorize, but proves particularly complex when we come to analyze it. Researchers such as Broydrick Thro have shown that the very description of the phenomenon leads to contradictions. The conflict is one of boundaries. The EYE first calculates contours (outlines) and, from these, shapes which are bounded. Confusion arises when, as in Figure 11, these contours serve a dual purpose.

The same situation arises in Figure 9 (itself an impossible object). In this figure, contour line l manifests itself both as the boundary

of volume A and as the boundary of volume B. It is not the boundary of both simultaneously, however. If our eyes fall first upon the upper half of the figure, *l* is perceived as the boundary of A and remains so until A opens out and is no longer a volume. At this point the EYE offers a second interpretation of *l*, namely that it is the boundary of B. If we follow the line back up to its start, our new conclusion will in turn be replaced by the first.

If this were its only ambiguity, we might be tempted to speak of a pictographically ambiguous figure. But it is in fact complicated by additional factors, such as the phenomenon of the figure vanishing into the background, and in particular the spatial notion of the figure formed by the EYE. In this connection you might like to take another look at Figures 7, 8 and 9 in Chapter 1.

Since these types of figure always manifest themselves as strongly spatial entities, we can provisionally number them as impossible objects and describe them – albeit not explain them – in the following general terms: the EYE calculates from these objects two different three-dimensional forms which are mutually exclusive and yet simultaneously present. Thus, for example, something can be seen in Figure 11 which seems to represent a solid pillar. At second glance, however, it appears as an opening, a spacious gap through which, as shown in the picture, a train can pass.

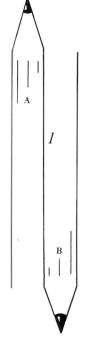

Figure 9

The impossible object as paradox

At the beginning of this chapter we met the impossible object as a three-dimensional paradox, i.e. as an image whose stereographic elements contradict each other. Before examining this paradox in greater depth, we should consider whether there is such a thing as a pictographic paradox. And indeed there is: think of mermaids, of sphinxes, of the fabulous beasts so often depicted in the art of the Middle Ages and early Renaissance. But it is not the EYE which is offended by such pictographic equations as woman + fish = mermaid; rather, it is our knowledge (in this case, of biology), accord-

ing to which such a combination is unacceptable. Only where spatial data in the retinal image are mutually conflicting is the "automatic" processing carried out by the EYE brought to a halt. The EYE is not prepared for the processing of such strangely structured material, and we witness the result as a new visual experience.

We can divide the spatial information contained in the retinal image (when looking through one eye only) into two classes, natural and cultural. The first class, which is also found in pictures, contains information over which the human cultural environment exer-

cises no influence. Such truths of "unspoilt nature", if you will, include the following:

- objects of the same size appear smaller, the further away they are. This is the basic principle of the linear perspective which has played a central role in art since Renaissance times;
- an object which partially obscures another object is nearer than that other object;
- where two objects or parts of objects are organically connected, both are equidistant from us;
- objects relatively far away from us will generally appear less distinct and will reveal a blue haze from an aerial perspective;
- the side of an object facing a source of light is brighter than the opposite side, and shadows point away from the source of light. In a cultural environment, two further factors play an important role in our assessment of space. We humans have created a living environment dominated by right angles. Our architecture, our furniture and many of our utensils are essentially constructed of rectangular cuboids. One might even say that we have compressed our world into a rectangular system of coordinates, into a world of straight lines, level planes and right angles. Our second, cultural class of spatial information is thus rigid and clear:

- a plane is a flat plane and continues as such until other details inform us that its continuity has been interrupted;
- corners at which three planes meet determine three main directions, in which connec-

10 Arthur Stibbe, "In front and behind", acrylic on cardboard, 50 x 50 cm, 1986

11 Fons de Vogelaere, "Passenger train", pencil drawing, 80 x 98 cm, 1984

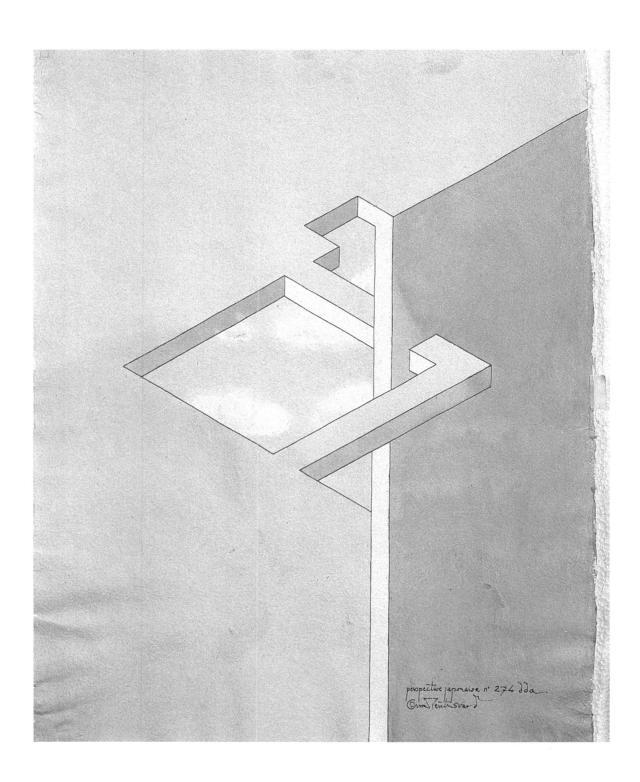

12 Oscar Reutersvärd, "Perspective japonaise n° 274 dda", coloured ink drawing, 74 x 54 cm

tion certain zig-zag lines can indicate an extension upwards or downwards.

In our context, the distinction between a natural and a cultural environment is a useful one. Our sense of sight developed in a natural environment, and yet it has the astonishing ability to process, smoothly and accurately, spatial information from the cultural category.

Impossible objects (or at least a large proportion of them) exist thanks to the presence of mutually contradictory spatial statements. In Jos de Mey's *Double-guarded gateway to the*

wintery Arcadia (p. 43, fig. 20), for example, the flat plane forming the upper section of the wall seems to disperse lower down into several different planes at varying distances from the viewer. This conflicts with the notion of the continuity of the plane. An impression of varying distances is similarly suggested by the overlapping of certain parts of Arthur Stibbe's *In front and behind* (fig. 10), something again officially prohibited by the rule of the continuity of the flat plane. In a watercolour by Frans Erens (p. 42, fig. 19), its perspective reduction in size in-

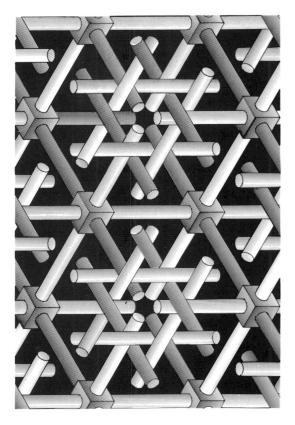

13a Harry Turner, from the series "Paradoxical patterns", mixed media, 1973-78

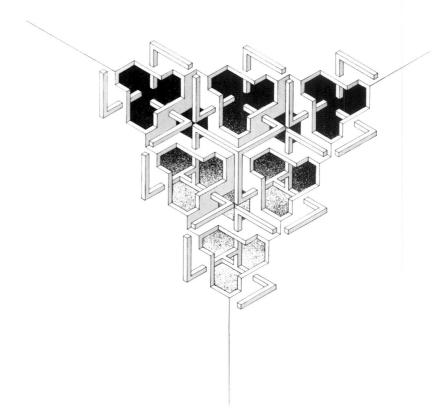

13b Harry Turner, "Corner", mixed media, 1978

14 Zenon Kulpa, "Impossible figures", ink/paper, 30 x 21 cm, 1980

15 Mitsumasa Anno, "A section of a cube"

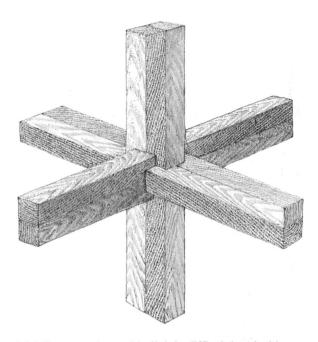

16 Mitsumasa Anno, "A slightly difficult interlocking wood puzzle"

17 Monika Buch, "Cube in blue", acrylic on wood, 80 x 80 cm, 1976

dicates that the plank is running horizontally into the background, yet it is attached to the post in such a way that it must be vertical. In the case of The five bearers by Fons de Vogelaere (fig. 21), we are struck by a number of stereographic paradoxes. Although the drawing is entirely free of paradoxical overlaps, it contains a number of paradoxical connections. The way in which the central figure is joined to the ceiling is particularly interesting. The five load-bearing figures link the ceiling and parapet in so many paradoxical ways that the EYE is sent on a restless search for a point from which best to assess them. You may be thinking that, with the aid of every possible type of stereographic element which can occur in a picture, it would be relatively simple to compile a systematic overview of impossible objects:

- those containing perspective elements which are in mutual conflict;
- those in which perspective elements are in

conflict with spatial information stated by an overlapping of forms;

. . . and so on.

We soon realize, however, that we can find no existing examples for many such conflicts, and at the same time that some impossible objects are difficult to fit into such a system. Such categorization might nevertheless enable us to recognize a number of still unknown types of impossible object.

18 Tamás Farcas, "Crystal", irisated print, 40 x 29 cm, 1980

19 Frans Erens, watercolour, 1985

Definitions

Let us conclude this chapter by attempting to give at least a working definition of impossible objects.

In my first publications on Escher's pictures of impossible objects, which appeared around 1960, I arrived at the following formulation: a possible object can always be construed as a projection, a representation of a three-dimensional object. In the case of impossible objects, however, no three-dimensional object exists whose representation is a projection; in this sense we may call an impossible object an illusory representation.

This definition is both incomplete and incorrect (a point we shall return to in Chapter 7),

because it refers only to the mathematical side of impossible objects.

Zenon Kulpa offers the following definition: the image of an impossible object is a two-dimensional figure which creates the impression of being a three-dimensional object, whereby this figure cannot exist as we spatially interpret it; thus, any attempt to construct it will lead to (spatial) contradictions which are clearly visible to the viewer.

Kulpa's last observation suggests one practical way of judging whether an object is impossible or not: just try building it yourself. You will soon see – perhaps even before you start – if it won't work.

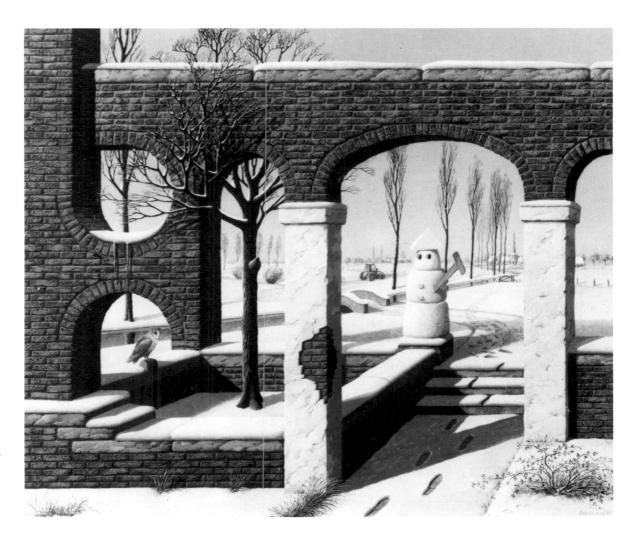

20 Jos de Mey, "Double-guarded gateway to the wintery Arcadia", acrylic on canvas, 60 x 70 cm, 1983

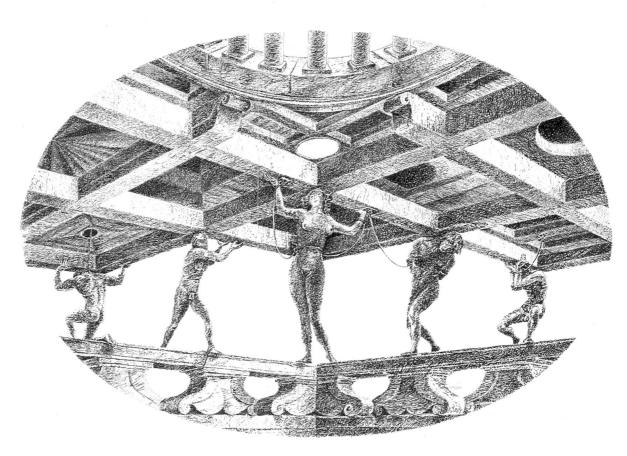

21 Fons de Vogelaere, "The five bearers", pencil drawing, 80 x 98 cm, 1985

I myself would prefer a definition which emphasizes that the EYE comes away from the impossible object with two contradictory conclusions: it is true and at the same time not true. I would like such a definition to em-

brace the reason for these mutually conflicting conclusions, and furthermore to make clear the fact that impossibility is not a mathematical property of the figure, but a property of its interpretation by the viewer.

22 Shigeo Fukuda, "Images of illusion", screen-print, 102 x 73 cm, 1984

On this basis I propose the following definition:

An impossible object possesses a twodimensional representation which the EYE interprets as a three-dimensional object, whereby the EYE simultaneously determines that it is impossible for this object to be threedimensional since the spatial information contained within the figure is self-contradictory.

23 Oscar Reutersvärd, "Cubic organization of space", coloured ink drawing, 29 x 20.6 cm. In reality this space is not filled, since the larger cubes are at no point linked to the smaller ones behind.

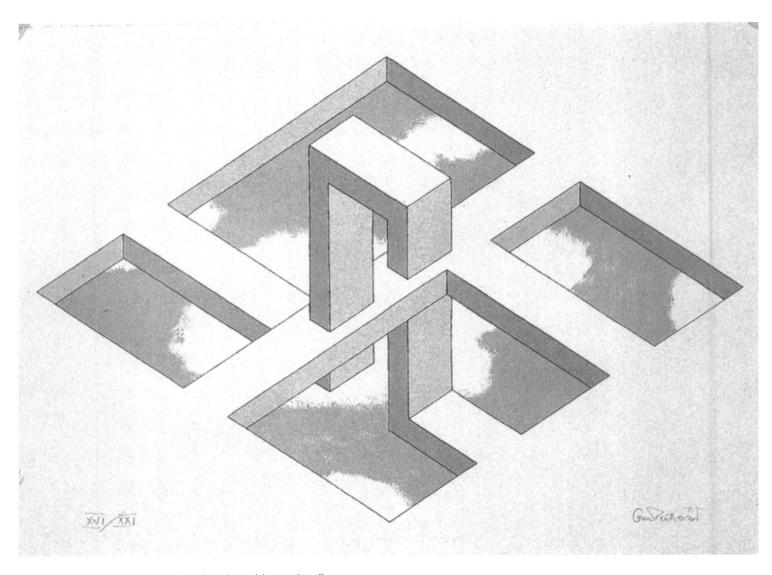

24 Oscar Reutersvärd, "Impossible four-bar with crossbars"

25 Bruno Ernst, "Mixed illusions", photograph, 1985

5 A gallery of impossible objects

In 1985, while Zenon Kulpa was working on an article on the categorization of impossible objects, *Putting order in the impossible*, I sent him a few new ones. His reaction was: "The more impossible objects are discovered, the harder it becomes to organize them into a rationally useful system."

Kulpa begins by dividing all two-dimen-

sional objects permitting or suggesting a three-dimensional interpretation into four categories:

1. *Possible objects*. These are perceived by the EYE as possible representations of 3-D objects; upon further appraisement, our faculty of reason also judges such objects to be realizable in three dimensions.

1 Hermann Paulsen, "Magic knot 1", gouache, 75 x 75 cm, 1985. The spatial depth suggested by the cubic structure of this sphere is merely an illusion.

2. Probable objects. The EYE calculates a possible and matching 3-D object; upon closer scrutiny, however, it becomes clear that the object cannot be realized in three dimensions. An example is the truncated pyramid shown below (fig. 3). Our EYE tells us immediately that this is a truncated pyramid, although it can be easily demonstrated why such an object is impossible: its three planes, when continued upwards, do not meet at a common apex.

Even after recognizing the rational truth of the situation, however, we cannot persuade our EYE to see something impossible, and for this reason the pyramid cannot be called an impossible object; if you refer back to my definition at the end of the previous chapter, you will see that it must be the EYE which decides whether an object – however impossible in reality – should indeed be assigned to the category of "impossible objects".

3. *Improbable objects*. The EYE's initial reaction is – impossible! But as soon as the possibility of spatial realization proffers itself from another angle, the EYE reacts by constructing an acceptable result. This is the case, for example, with the small block shown in Figure 4. If we tell our EYE that a small section has been cut out of the edge at a slant, it will accept this information and resume normal operation, particularly if we can also show it a three-dimensional model of this "impossible" block.

4. *Impossible objects*. The EYE immediately identifies the spatial contradictions inherent in the figure; these are only later confirmed by rational assessment. Both the EYE and the reason judge the object to be impossible. In this case it is a true impossible object.

These thoughts lead us to the question: is there any kind of objective yardstick which we can apply to tell us whether an object is impossible? Various experiments have been carried out in an attempt to establish, on a purely mathematical basis, criteria which might allow impossible objects to be defined and categorized. It is no surprise that they failed. For here, too, the EYE plays a dominant role – and the mechanisms of the EYE, developed over the course of evolution in order to guarantee the greatest possible

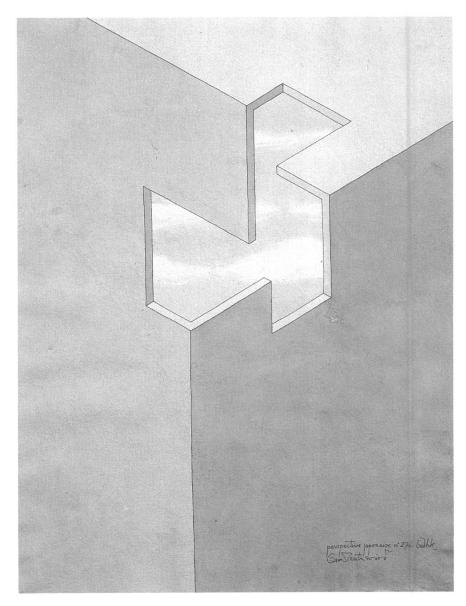

chances of survival, by no means operate along simple mathematical lines.

By acquainting ourselves more thoroughly with the "decision-making processes" of the

2 Oscar Reutersvärd, "Perspective japonaise n° 274 badhk", coloured ink drawing, 75 x 55 cm

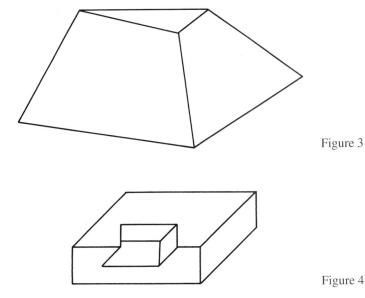

5 Dirk Huizer, "Looking in – Looking out", irisated screenprint, 49 x 49 cm, 1983

EYE, we will be in a better position to discuss the topic with others. Let us therefore try the following useful exercise:

Imagine a horizontal plane S slicing through an object, as in the case of the impossible triangle shown in Figure 6a. Cover the half of the object below the line with a piece of paper, and then draw the cross-section of the upper half of the figure at S. Now cover the top half of the object, and draw the cross-section of its lower half at S. If your sketches differ in any way, you are dealing with an impossible object. In such cases, the EYE has clearly composed an object from parts which are mutually exclusive as soon as they are combined.

In order to demonstrate the usefulness of this method as a means of detecting non-match-

Figures 6a/b

ing – and hence impossible – cross-sections, a few more examples are included here: Ernst's two-bar (fig. 6b), a normal four-bar (fig. 6c), an impossible cube (fig. 6d) and an impossible tuning fork (fig. 6e). The method proves less successful in the case of *probable* objects; if you apply the experiment to the truncated pyramid of Figure 3, for example, you will obtain corresponding cross-sections!

Meanwhile, we have still come no closer to creating specific categories of "real" impossible objects. Zenon Kulpa reaches no conclusions; he is obliged to make do with overlapping categories compiled ad hoc from a jumbled mixture of criteria. Only the categories "Multi-plane" and "Objects with parallel bars" offer useful subdivisions.

We, too, will be avoiding specific classifications in this chapter. We shall offer no more than a very incomplete overview, in which our grouping of objects makes no claim to be definitive. Our aim thereby is simply to trace a clear and logical path through our subject.

Figures 6c-e

Apparent filling of space with impossible tri-bars

At first sight, Reutersvärd's composition on p. 45 bears a number of similarities to Escher's *Cubic division of space* from the year 1952. But Reutersvärd's work in fact represents a network of impossible tri-bars in which the large cubes hang like a curtain in the foreground, unconnected to the cubes in the second row.

These may thus be seen as a second curtain behind the first, followed in turn by a third curtain of even smaller cubes. Hermann Paulsen uses closed, curving tri-bars (p. 47, fig. 1) to suggest the filling of a spherical volume. The reduction in size of the impossible tri-bars towards the edge of the circle is cleverly achieved!

Overlapping planes

We have already observed that the spatial contradictions within an impossible tri-bar can be traced back to a fundamental principle of stereometry, namely that three non-parallel planes intersect at a single point. In the drawing by Oscar Reutersvärd (p. 48, fig. 2) we see three such planes appearing to form a corner of a rectangular volume. But if we extend these planes across the opening which interrupts them, we find that they intersect at different points. This inconsistency goes un-

noticed precisely because pieces have been sawn out of the corners of the planes. The opening thereby created is itself an impossible object. The six planes in Huizer's picture (p. 49, fig. 5) pose no problem in themselves. Their spatial arrangement is only rendered impossible by the tri-bar by which three of them are connected. Despite its apparently simple composition, the picture offers an unfathomably mysterious glimpse of illusory space.

Mono-bars, two-bars, and something in between

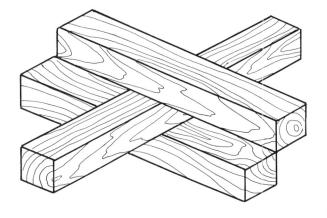

7 Bruno Ernst, "Impossible penetrations", 1984

Figure 8

9 Zenon Kulpa, "2½-dimensional beam, or 1=2", 1984

10 Bruno Ernst, "Impossible two-bar"

One might ask whether such a thing as an impossible monobar can exist at all. Figure 8 shows a normal bar at the top, followed by a bar with both sawn-off ends visible and, at the bottom, a bar with neither of its sawn-off ends visible. These last two are naturally impossible, but the EYE is determined to see them as bars with their ends sawn off at a slant; therefore, according to our earlier classification, they are not impossible objects!

In his drawing *Gateway to the fourth dimension*, (p. 52, fig. 12), Sandro del Prete nevertheless finds a way of making such bars into impossible objects by adding a number of spatial details. All four bars run away from us; of all the objects visible in the picture, the figure of the woman is the closest. The bars share another curious characteristic: each plane is simultaneously both horizontal and vertical, depending on the side from which it is seen first. This peculiarity is emphasized by the inscriptions on the bars.

In Figure 7, an otherwise entirely normal bar has been rendered impossible by its setting: it passes between two other bars which in fact allow it no room to do so, since their edges are hermetically sealed along one side.

The object in Figure 9 was invented by Zenon Kulpa. At first glance we seem to see two parallel bars – only to lose the right-hand bar as it melts into the shadow of its neighbour. Perhaps this is best described as an impossible one-and-a-half bar!

In the case of Ernst's impossible two-bar (fig. 10), the middle "rectangle" reveals a dual orientation: it appears vertical at the front and horizontal at the rear. Its interpretation is determined by the spatial information provided in the immediate vicinity of the outer ends of the two-bar.

Sandro del Prete's *Cosmic wheels* (fig. 11) can also be seen as an impossible (curved) two-bar. It bears resemblances to Escher's *Cube with magic bands* (p. 75, fig. 16).

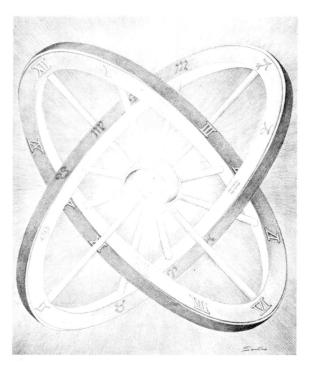

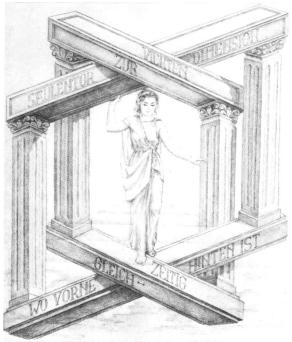

- 11 Sandro del Prete, "Cosmic wheels", pencil drawing
- 12 Sandro del Prete, "Gateway to the fourth dimension", pencil drawing

Impossible rooms

I drew *Fifty Years Impossible Figures* (fig. 13) as a jubilee poster for Oscar Reutersvärd. The opening in the upper corner of the room is impossible, because the three planes (the two walls and the ceiling) do not meet at a single point. Reutersvärd's first im-

possible object, an impossible tri-bar composed of nine cubes, appears as a heavenly body in the background. When Jos de Mey saw the poster, he drew his own – to my mind, typically "Flemish" – version of the composition as a Christmas card (fig. 14).

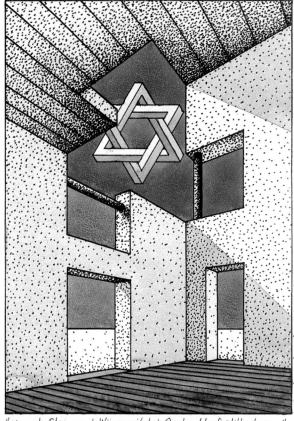

"Waar de Ster, van de Wijzen uit het Oosten, bleef stille staan ..."

- 13 Bruno Ernst, poster design, 1984
- 14 Jos de Mey (after Bruno Ernst), coloured ink drawing, 27 x 19.5 cm, 1985

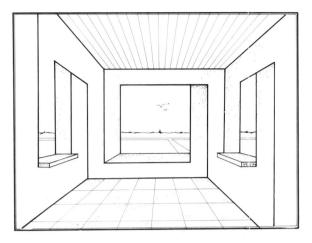

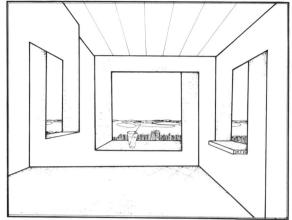

15 and 16 Bruno Ernst, "Strange rooms"

Reutersvärd's original tri-bar is replaced by a star made up of two interwoven impossible tri-bars, and the picture is shown in centralized rather than false perspective.

The *Strange rooms* of Figures 15 and 16 are again based on the fact that three planes in-

tersect at more than one point. In both pictures this produces side walls which simultaneously face towards us. In Figure 15, moreover, one of the solid walls vanishes into thin air, although the illusion of a room nevertheless remains perfectly convincing.

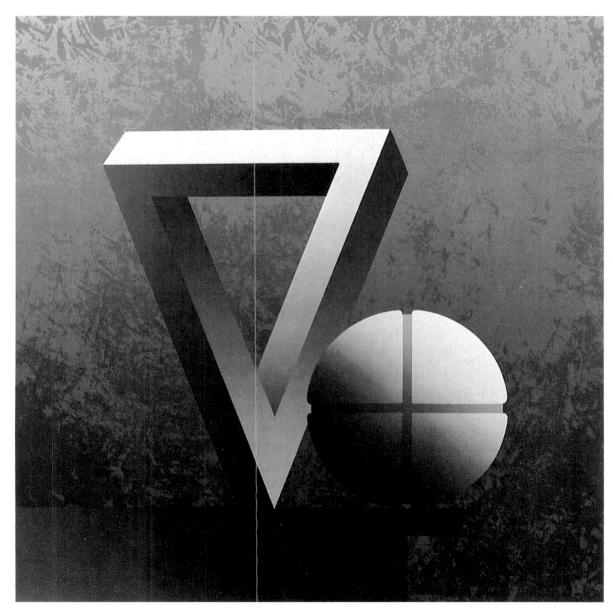

17 Dirk Huizer, "Penrose triangle and imperial orb", irisated screenprint, 45 x 45 cm, 1984

Tri-bars: alone and in relation to their surroundings

An impossible tri-bar can serve as the subject of a picture without further accessories, as can be judged from Dirk Huizer's screenprint (fig. 17).

In Figures 18-20, on the other hand, the environment within which the tri-bar appears plays an important role. Figure 18 shows an impossible tri-bar standing in the hall of my apartment. Reutersvärd promptly responded to this drawing with an interesting variation (fig. 19), in which the tip of the tri-bar is partially obscured by a ceiling support, thereby also altering the line of shadow it casts. In-

spired by this, I then drew Figure 20; I added a few more impossibilities to the room, which had now developed into a museum gallery with impossible objects hanging on its walls. But there were clearly serious difficulties involved in exhibiting a "real impossible tri-bar"!

Figure 21 shows a variation upon the usual impossible tri-bar, in a setting borrowed from a drawing by Macaulay. It now shows the Moon in the year 2034, where the finishing touches are being put to a monument celebrating 100 years of impossible tri-bars.

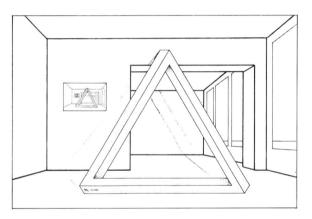

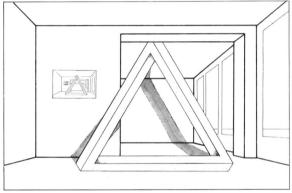

- 18 Bruno Ernst
- 19 Ernst/Reutersvärd

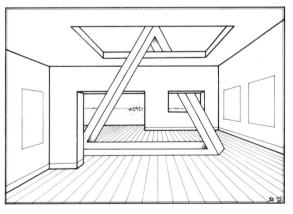

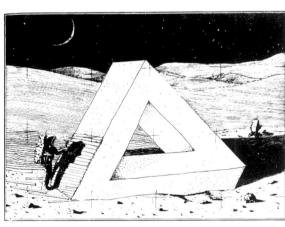

- 20 Bruno Ernst
- 21 Ernst/Macaulay

Impossible multi-bars

Figure 22 represents a solid frame which is above and to the left of our viewpoint. From this angle each corner is seen differently, as if one of four distinct corner types which can be numbered 1-4.

The frame as a whole can thus be described

as (1234). By employing these individual corners in different combinations, we can build frames in which the EYE will discover contradictory spatial data. The two drawings to the right of Figure 22 show two impossible four-bars of this type. One has a

corner combination of (4444) and the other, (4141).

Using the same principle, it is not difficult to combine more than four bars into an impossible figure.

It is interesting to note, however, that multibars produced in this way are less tantalizing as impossible objects than impossible tri-bars and four-bars. First, the suggestion of right angles in an impossible object, e.g. through a perpendicular combination of bars, gives the EYE a useful reference point from which to determine directions in space, and any contradictions will thereby be made more apparent. The arms of a multi-bar, however, always meet at an angle that is greater than 90°; spatial directions are therefore harder to determine. Secondly, the more bars and lines that there are in a structure, the less its contradictions will strike the eye. Multi-bars, however, are very simple in design. In Figure 23 we see one five-bar (13143), one six-bar (444444), and the curved two-bar (44) which we met earlier in Figure 11.

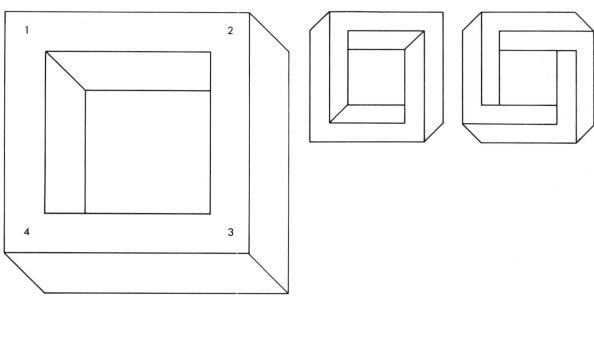

Figure 22

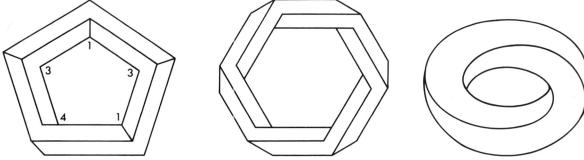

Figure 23

Four-bars

The four-bar in its classic form is shown in Figure 31. It belongs to the (3441) type, and its building-block composition lends it a particularly realistic character. The surface area and volume can again be calculated: 76 dm² and 19 dm³. We can experiment with this figure just as with the impossible tri-bar in Chapter 4 (pp. 33-37). Meanwhile, Figure 30 gives you all the parts you need to build an impossible four-bar; you simply have to screw them all together!

The combination of an impossible four-bar with a normal four-armed cross highlights the fact that the top and bottom bars appear perpendicular to one another (fig. 24). Dirk Huizer's impossible stringed instrument (fig. 25) is made up of impossible tri-bars and four-bars, and a normal four-bar.

A four-bar can also serve happily as a megalithic monument (fig. 27); the setting is again borrowed from a drawing by Macaulay.

Everyday objects can further be combined into impossible objects by overlapping them in impossible ways (figs. 26 and 28).

25 Dirk Huizer, "Still life no. 3", irisated screenprint, 44 x 44 cm, 1983

26 Diego Uribe

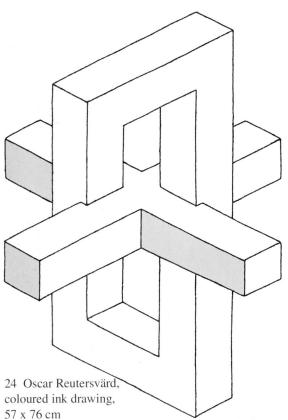

27 Macaulay/Ernst, "Megalithic monument", ink drawing

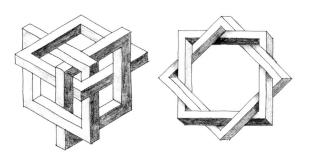

28 Dirk Huizer, small sketches from his correspondence with the author

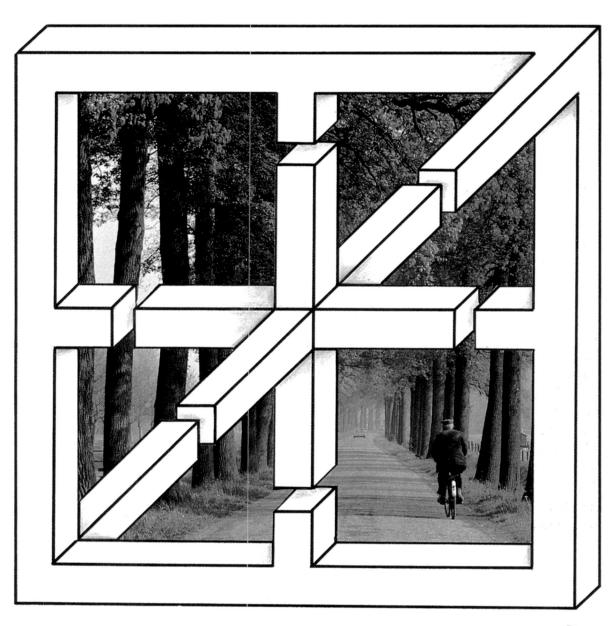

29 Bruno Ernst, collage, 1984

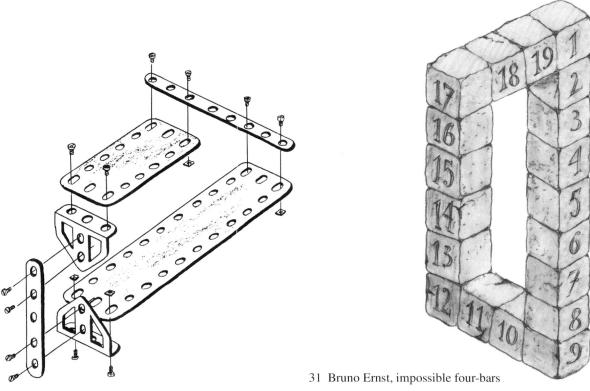

30 Govert Schilling, ink drawing, 1984

Multi-bars as jigsaws

Various jigsaws have been designed whose pieces allow the player to make up every possible and impossible type of tri-bar, four-bar, etc. The most obvious method is for the puzzle pieces to illustrate all the possible corner shapes in such a way that one bar of one hexagon always joins onto a bar of another hexagon.

Diego Uribe has designed a much more sophisticated solution, opening up many more possibilities with much less effort. He uses not complete corner shapes, but bar elements instead, which he places along the edges of equilateral triangles. It is possible to make up every possible multi-bar with just thirty-two different triangles (fig. 32), including not only the multi-bars we have already seen, but also figures in which more than two bars meet at one corner, such as in impossible cuboids. There is but one limitation: only perpendicular relationships are possible between the bars within an object. Figure 33 shows you how to combine the pieces into an impossible four-bar, while Figure 34 shows a more complex form in which three bars meet at one corner.

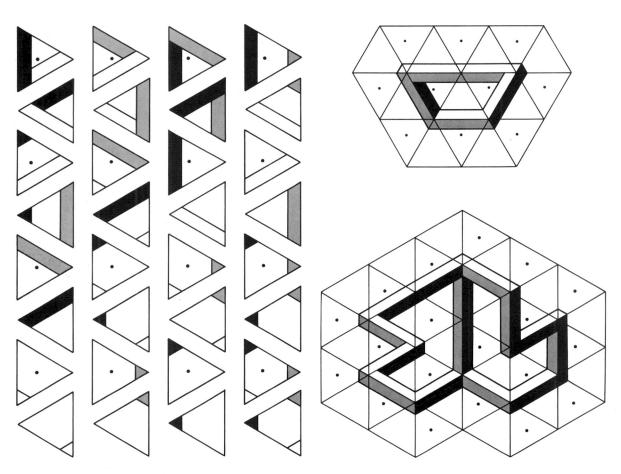

32, 33 and 34 Diego Uribe, design for a jigsaw puzzle; the individual pieces (left) and two figures made from them (right)

Cuboids

Escher was the first to draw an impossible cuboid (cf. Chapter 6, p. 74). As in the case of multi-bars, a wide range of rather different cuboids can be composed using the corner types of the – normal – original (cf. fig. 35). Figures 36 to 42 show a selection of

variations on the theme of impossible cuboids.

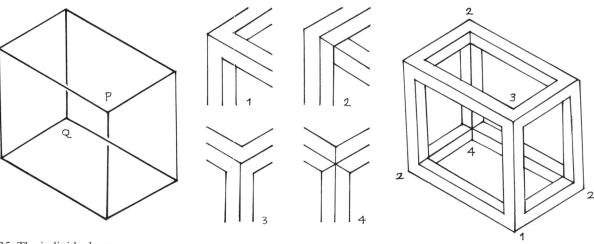

35 The individual corners (centre) of a normal cuboid (right) can be combined into impossible objects (below).

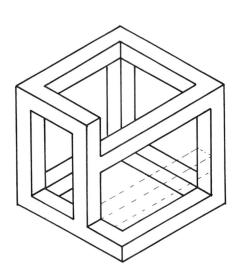

Figure 36

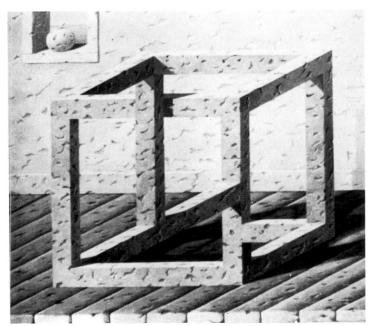

37 Jos de Mey

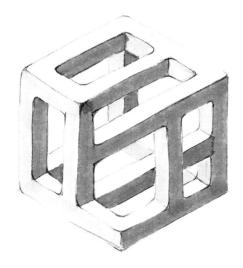

Figure 38

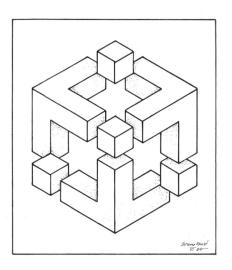

Figure 39

Steps and chessboards

If we walk through the centre of the – in actual fact, impossible – doorway in Figure 43, we remain on the same horizontal plane, standing on a tiled floor. If we look left, how-

We see the same effect in the photograph of the chessboard (fig. 44). If we move from the White Knight via the Castle to the King, we stay on the same level. In moving directly ever, our path seems to lead up some steps. from the White Knight to the King, however, we gain the impression that the King is standing on a higher level than the Knight. In reality everything is flat!

A number of impossibilities have been incorporated into Figure 45, a screenprint by Fred van Houten. Take the ladder, for example: it starts against the wall - and ends beside it. Escher makes similar use of a ladder in his Belvédère (Chapter 6, fig. 18).

44 Bruno Ernst, "Chessboard I", 1985

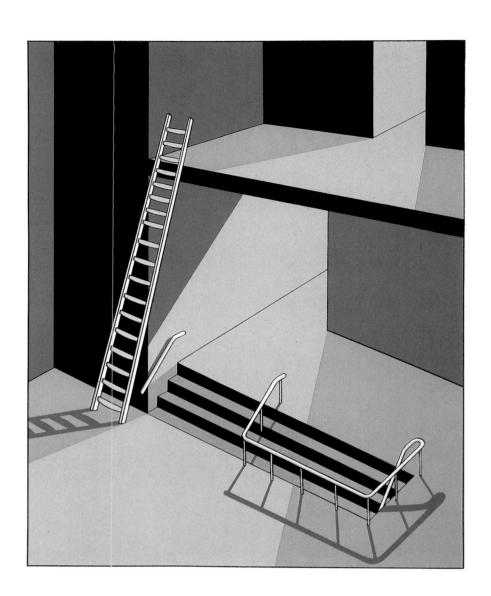

45 Fred van Houten, "Steps", screenprint, 30 x 24 cm, 1984

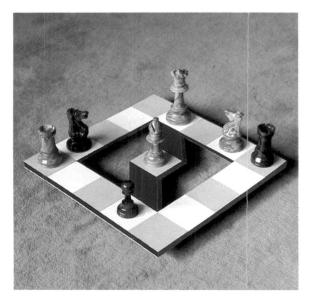

46 Bruno Ernst, "Diagonal", photograph, 1985

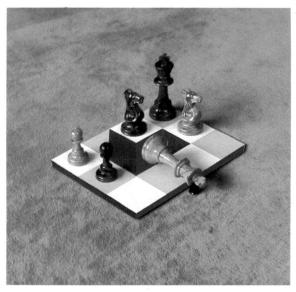

47 Bruno Ernst, "Spiral", photograph, 1985

Multiple planes

A multiple plane looks like a single, flat plane when viewed from one point in a drawing, and yet appears to consist of two or more planes when seen from another point in the same drawing. This is the oldest type of impossible object; as we shall see in the next chapter, it appears – unintentionally or unconsciously - in works by much earlier artists. Figure 48 demonstrates how a multiple plane can be created. At the top, we see an archway standing on a tiled floor. Consulting the plan of this floor reproduced in the bottom left-hand corner of this page, we see that the left-hand foot of the arch is standing on the black square, and the right-hand foot on the square marked number 2. Let us now redraw the same archway, but making its righthand side slightly shorter so that it ends on square 3. We have immediately created an impossible object: the seemingly flat front view of the archway contains two base lines, a and b – and that is impossible. We can continue to shorten the right-hand side until it reaches square 5. The archway has now become part of an impossible four-bar, here achieved by a different method than that described earlier. In the drawing by Jos de Mey (fig. 49), the upper section of the wall forms just a single plane with three diamondshaped openings. At ground level, however, the same plane multiplies into four walls at varying distances from the viewer, at the same time enclosing a relatively large space, almost as if it were a roofed pergola.

In Figure 50 we see how the side plane of a cube can duplicate itself to make room for ever smaller cubes.

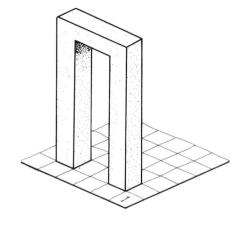

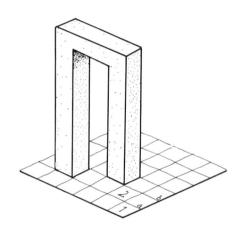

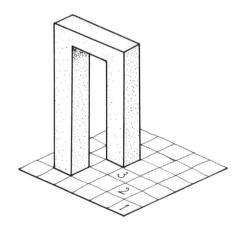

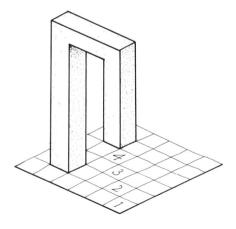

Figure 48

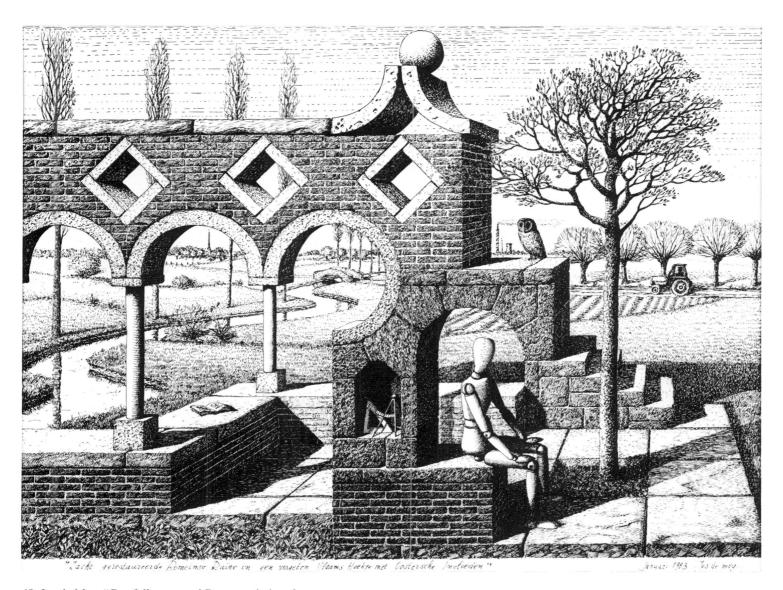

49 Jos de Mey, "Carefully-restored Roman ruin in a forgotten Flemish locality with Oriental influences", ink drawing, $30 \times 40 \text{ cm}$, 1983

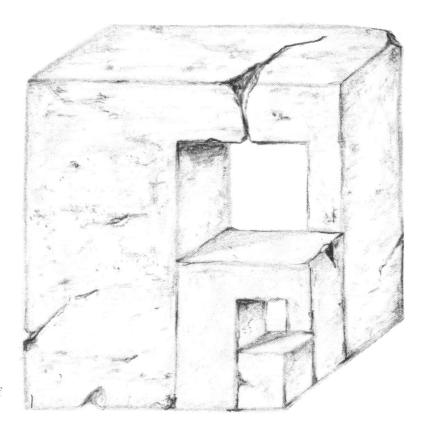

50 Bruno Ernst, "Nest of impossible cubes", 1984

Continuous steps

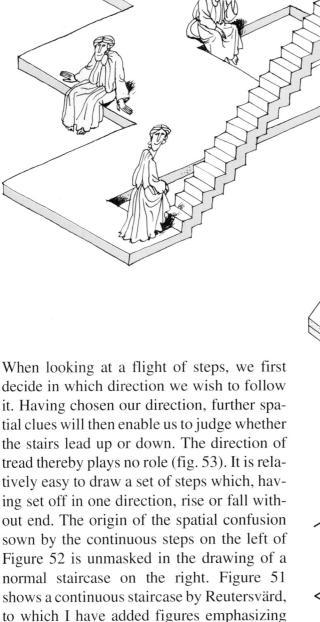

51 Reutersvärd/Ernst, "Caryatids"

Figure 52

Figure 53

the impossibility of the situation.

54 Bruno Ernst, "Negative sound", 1984

Planes with two orientations

The astonishing nature of this type of plane is illustrated by the following example: the small temple shown in Figure 55 can be mounted from the left in just two steps. Approached from the middle, however, there are three steps to ascend, and no less than five on the right. The steps leading up to the temple are in fact composed of three elongated "rectangles" aligned in two different directions. This has the effect of making the immediate surroundings appear as a vertical plane on the left and a horizontal plane on the right.

This type of plane is not warped, but the EYE calculates its orientation on the basis of details gathered from the immediate setting, and thus in two different ways. Similar planes occur in Reutersvärd's *Layered blocks* (fig. 56).

55 Bruno Ernst, "The wearisome and the easy way to the top", 1984

57 "Stair blocks", after Roger Penrose

56 Oscar Reutersvärd, "Layered blocks"

Penrose's circular staircase

In 1985 Roger Penrose designed a combination of five impossible cuboids; Figure 57 represents one of its variations. Flights of steps lead from one cube to the next, but if we set off on a circuit standing upright, we will regain our starting-point horizontal! Life returns to normal in a similar arrangement of six cubes, but the strange phenomenon reappears in the case of seven.

From ambiguous figures to impossible objects

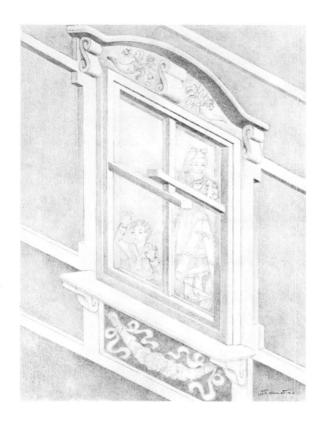

58 Sandro del Prete, "Children looking out of the window", pencil drawing

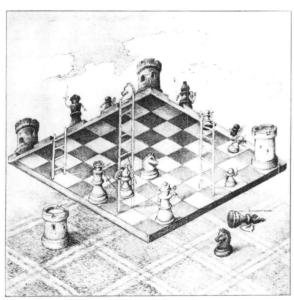

59 Sandro del Prete, "The inverted chessboard", pencil drawing

A rhombus such as Sandro del Prete's chess-board (fig. 59) is an ambiguous figure: it is a square seen from either above or below. The positioning of its chessmen and ladders creates an impossible "both/and" situation, however, with both "above" and "below" interpretations presented simultaneously and in mutual contradiction. The peculiarity of the situation becomes clear when we move the White Castle square by square "diagonally upwards" along the edge of board.

A similar example of the transformation of an ambiguous figure into an impossible object is seen in Figure 58. Taking the window frame on its own, it can be seen either as a window facing west viewed from above, or as a window facing south viewed from below. Both interpretations are reinforced by secondary spatial clues found in the decoration of the windowsill, the ornamentation over the top of the window and the two separate halves of the window cross. The two incompatible view-points are fused by the figures we see inside the house: we are able to perceive the entire composition at once and both from above and below.

"Two arrows"

Boundary conflicts

"False candles", 1984

We offer three examples of a type of impossible object in which matter appears to vanish into thin air, the so-called "devil's fork" type.

The tuning fork in Figure 54 (p. 65) in fact has only one solid arm; the sound waves are therefore shown as if issuing from the sha-

dow of this impossible object. Some of the arms of the candlestick in Figure 61 similarly appear not to exist. And it is impossible for Reutersvärd's two arrows (fig. 60) to have four ends. Yet how many bars does it truly contain – two, or three? On no account four!

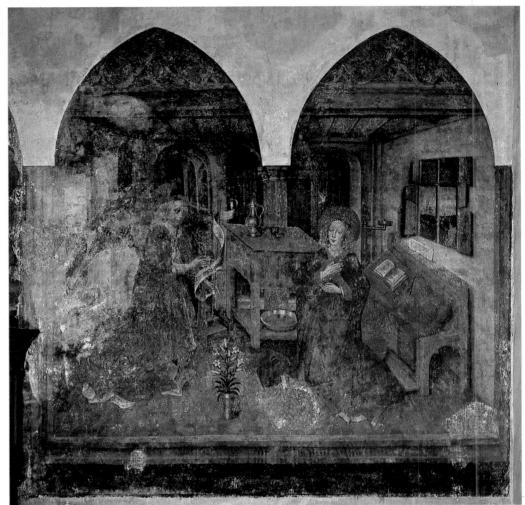

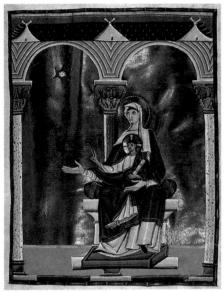

During the search for impossible objects existing prior to 1934, the year in which Oscar Reutersvärd began to concern himself consciously with the subject, it emerged that such objects were chiefly to be found in art of the age before the advent of classical perspective. They were created unconsciously, but always for a specific purpose. The oldest example known today is found amongst some miniatures from the Pericope of Henry II, compiled before 1025 and now preserved in the Bayerische Staatsbibliothek in Munich. The Madonna and Child shown above left, taken from an Adoration of the Magi, contains a central pillar which ought to end in the foreground. If it did, however, it would obscure our view of the enthroned Virgin. Instead, the top half of the pillar appears in the front pictorial plane, but the bottom half is depicted in the rear, creating an impossible object of the

"multiple plane" category. Another important example is found in the 15th-century fresco of an Annunciation in the Grote Kerk in Breda (above right; cf. also p. 85). Art historian J. Kalf was the first to note something odd about the central pillar. This impossible object seems closely related to the Pericope miniature, both in terms of its character and the reason for its invention.

6 Origins and history

The conscious construction of an impossible object is a relatively new phenomenon. In 1934 Oscar Reutersvärd drew the first impossible tri-bar. Escher invented the impossible cube in 1958 and incorporated it into his lithograph, *Belvédère*. The article by Penrose and his son on the impossible tri-bar structure and the continuous flight of steps appeared that same year; Escher took these two figures as the models for his *Waterfall* (1961) and *Ascending and descending*

(1960). We have a relatively clear overview of these more recent developments thanks to information received by the author at first hand.

We shall be seeing in the second part of this chapter, however, that impossible objects, whether created consciously or unconsciously, have existed in art for a considerably longer period. Indeed, the earliest known examples date from as far back as the 11th century.

Oscar Reutersvärd: the Nestor of impossible objects

Remarkably, Reutersvärd drew his first impossible object quite by chance. Nevertheless, he quickly realized that the figure possessed special, previously undrawn proper-

Opus I Orentenvirol ja 1734

1 Oscar Reutersvärd, "Opus 1 n° 293 aa", 1934

ties. He takes up the story in the following excerpts from his own letters on the subject: "At senior school I had Latin and philosophy instead of maths and biology. In our Latin lessons, while the teacher was offering edifying observations on the Romans, virtually every pupil would be doodling in the blank margins of his Latin grammar. I used to try drawing stars with four, five, six, seven or eight points that were as regular as possible. As I was elaborating a six-pointed star with a circle of cubes one day, I discovered that the cubes had formed a strange constellation. Driven by an inexplicable impulse, I added another three cubes to the configuration, in order to make a triangle. I was sharp enough to realise that I had thereby drawn a paradoxical figure. After the class I showed it to one of my schoolmates, Jan Cornell, because he was my friend and was mad on maths. 'I've never seen anything like that before!', he cried. 'You must look it up in a mathematical encyclopaedia right away; you're bound to find something on such extraordinary geometric objects!' I hurried to the Stockholm municipal library, where I sought in vain for examples of objects with the same remarkable characteristics.

Over the next few years I occasionally played with the possibilities of 'cubes in paradoxical combinations', creating the endless staircase and figures of the devil's fork type. My devil's fork was slightly different, by the way, to the figure subsequently published by

Schuster; mine was derived from impossible meanders (p. 81, fig. 29). At the time I called my figures 'illusory bodies'.

In 1958 the same Jan Cornell (now a well-known publisher) gave me an article to read in which the two Penroses introduced a number of impossible objects; it was only then that I realized what I had actually discovered as a boy. Up to that point I had drawn about a hundred impossible objects, but the Penrose article inspired me to begin a thorough exploration of the field. I have drawn a total of approx. 2500 impossible objects between then and now [1986]."

Reutersvärd's account of how he arrived at the endless staircase also sheds light on the way in which his impossible objects arose in the form of related series: "A few days before making the journey from Stockholm to Paris (May 1950), I heard on the radio an interesting programme on Mozart's method of composition. His manner of working was described as 'creative automatism'. Each musical inspiration that he wrote down itself inspired a new idea, and this another, and so on. I felt this was an apt description of the way in which I myself developed impossible objects. I decided to note the time and place of origin on a sequence of impossible objects which I drew during my journey in this 'unconscious', automatic way. It was an arduous experiment, but one that was both interesting and fruitful, and which enabled me to trace the development of increasingly complex figures step by step. I produced fourteen

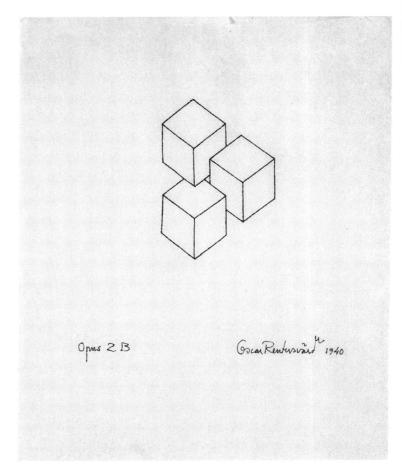

drawings during the almost 40-hour trip. Strangely enough, I did not realise at the time that the figure was in fact a continuous flight of steps. I only consciously began to address the subject some years later" (cf. figs. 3-5). Writing about Escher, Reutersvärd acknowledged: "I am a very, very great admirer of Escher. I saw one of his impossible objects for the first time in 1961, when Jan Cornell sent

2 Oscar Reutersvärd, "Opus 2B", 1940

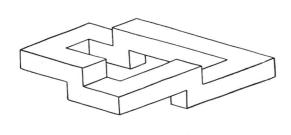

nr. Z

aderé à 22h40 enhe Södatätje et Katrinekolm

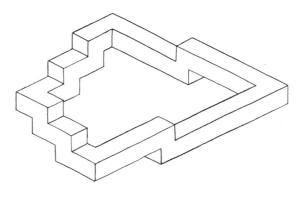

achevé à 20t 40, 11 Mai, 95 km. an sud de Hamboury

Oscar Reichersond

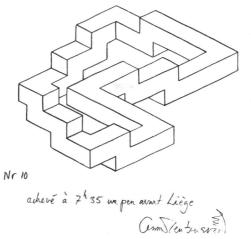

me his Ascending and descending. I was very impressed by it, although not so much by the irregularity of the stairs $(2 \times 15 + 2 \times 9)$.

In 1962 Cornell sent me a reproduction of Escher's Waterfall, a remarkable composition in which I particularly admired Escher's treatment of the tri-bar theme. In 1963 and 1964 I wrote Escher two letters, in which I expressed my admiration for his work. He did not reply. I sent him extracts from articles on his work appearing in Swedish newspapers, but again he failed to respond."

Figure 5

Drawing something truly impossible

6 Stockholm 1934: Oscar Reutersvärd (right) and Jan Cornell (second from left)

7 Oscar Reutersvärd, 1950

At the Escher Congress in March 1985 in Rome, I talked to Roger Penrose about the role which he and his father had played in rediscovering the impossible tri-bar structure and the continuous steps. He seems to have been greatly inspired by Escher's work, although at that time Escher had not yet drawn any impossible objects, and indeed had no idea even of their existence. Penrose tried drawing a truly impossible object for himself. As he explains: "My own interest in impossible objects stems from the year 1954, when, as a research student, I attended the International Congress of Mathematicians in Amsterdam. I knew one of the speakers, and he remarked that I might be interested in an exhibition of works by the Dutch graphic artist M.C. Escher, an exhibition which had deliberately been organized to run parallel to the congress. I went to see it, and I remember that I was absolutely spellbound by his work, which I was seeing for the first time.

On my journey back to England, I determined to make something 'impossible' myself. I experimented with various designs of bars lying behind and in front of each other in different combinations, and finally arrived at the impossible triangle (later known as the impossible tri-bar) which, it seemed to me, represented the impossibility which I sought in its purest form.

Although Escher had many extraordinary things on display in his exhibition, there was nothing which we would today call an impossible object.

I showed my father the above-mentioned triangle at the next possible opportunity. He immediately sketched a number of variants and eventually came up with the drawing of an impossible flight of stairs leading continually downwards (or upwards). We wanted to publish our findings, but had no idea how or where, since we didn't know what field our subject fell into. It then occurred to my father that he knew the editor of the British Journal of Psychology and could ask him whether he would print our article. We decided, therefore, that it was a psychological subject, and sent him our short manuscript. It was published in 1958. We acknowledged the catalogue of the Escher exhibition which I had seen in Amsterdam. When the copies appeared, we sent one to Escher as a token of our esteem. At that time none of us knew of the much earlier work by Oscar Reutersvärd, which I only discovered in 1984." The much-

8 Roger Penrose, Rome, 1985 (photo: Bruno Ernst)

discussed article by the two Penroses is reproduced in full below.

"Impossible Objects: A Special Type of Visual Illusion"

By L.S. and R. Penrose, University College, London, and Bedford College, London. (Manuscript received 30 November 1956)

"Two-dimensional drawings can be made to convey the impression of three-dimensional objects. In certain circumstances this fact can be used to induce contradictory perceptual interpretations. Numerous ideas in this field have been exploited by Escher (1954). The present note deals with one special type of figure. Each individual part is acceptable as a representation of an object normally situated in three-dimensional space; and yet, owing to false connexions of the parts, acceptance of the whole figure on this basis leads to the illusory effect of an impossible structure. An elementary example is shown in Fig.[9]. Here is a perspective drawing, each part of which is accepted as representing a three-dimensional rectangular structure. The lines in the drawing are, however, connected in such a manner as to produce an impossibility. As the eye pursues the lines of the figure, sudden changes in the interpretation of distance of the object from the observer are necessary. A more complicated structure, not drawn in perspective, is shown in Fig.[10]. As this object is examined by following its surfaces, reappraisal has to be made very frequently.

Another way of presenting the same type of illusion is to express the impossibility in terms of such a phenomenon as a continually descending or ascending path. The flight of steps drawn in Fig.[11] is an example of this. Each part of the structure is acceptable as representing a flight of steps but the connexions are such that the picture, as a whole, is inconsistent: the steps continually descend in a clockwise direction.

Actual objects suitably designed, viewed from particular angles, can give exactly the same impressions as inconsistent drawings. A photograph of a model of this kind, apparently an impossible staircase, is shown as Fig.[12]. Actually the far right hand step was much nearer to the camera and much higher than the step which appears to be just above it. Illusions with a different purpose, constructed in a somewhat similar manner, have been discussed by Kilpatrick (1952)."

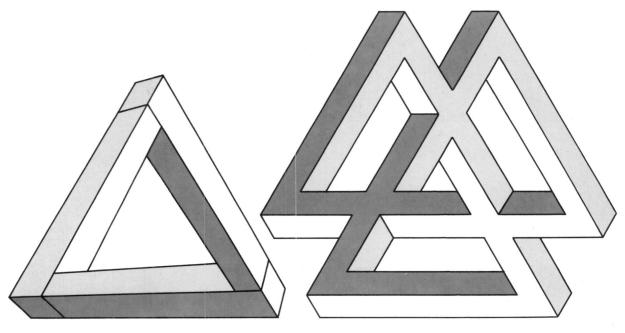

Figure 9 Figure 10

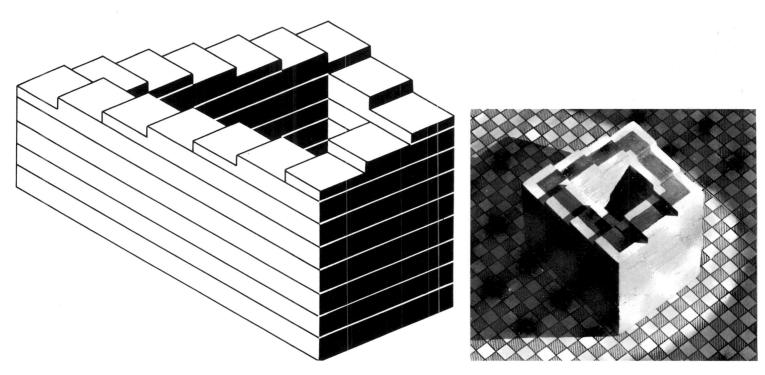

Figure 11 Figure 12

References:

Escher, M.C. (1954): *Catalogus 118;* Stedelijk Museum, Amsterdam.

Kilpatrick, F.P. (1952): "Elementary demonstrations of

perceptual phenomena". In *Human Behavior from the Transactional Point of View.* Hanover, N.H.: Institute for Associated Research.

Escher's impossible cube

When Escher started working on his lithograph *Concave and convex* in 1955, he was already thoroughly acquainted with the ambiguity of the Necker cube; he was looking for a means of combining the constantly alternating orientations of the cube into an object which allowed two mutually exclusive interpretations at once, and was thus impossible. He succeeded most happily in 1957, with his *Cube with magic bands* (fig. 16). The preliminary studies for this picture show that Escher was already relatively adept at handling impossible tri-bars.

One year later, Escher invented an impossible cube in which the Necker cube is no longer ambiguous but has become a "stable" impossible object. He thereby drew upon the discoveries which he had made in the field of impossible connections of bars. His first sketches on the theme do not yet employ impossible overlapping, but in the final form, which he used for the picture *Belvédère*, such overlapping is present. The ingenious structure of this impressive picture (known as the "Phantom House" in its early stages) deserves closer examination.

In Chapter 5 we met the principle according to which large numbers of impossible cuboids can be constructed. The majority – including the version which Escher chose for his *Belvédère* – are positively taxing on the viewer. The EYE tries to make something of them, but its efforts are thwarted by the blatant contradictions built into their geometrical details. Only through the harmonious interplay of such impossible elements with additional perspective information can the picture as a whole reveal the beauty of the impossible cube – and hence the reality and magnificence of the impossible!

Escher was a master of this art. Examining his *Belvédère* (p. 77, fig. 18) more closely, we are struck by the very unobtrusiveness of the impossible cuboid at the centre of the composition; its horizontal planes are long and narrow, while those of its parts having contradictory spatial orientations lie far apart and are even camouflaged. This is not at all the solution we might expect, since it seems

13 M.C. Escher, 1958 (photo: Bruno Ernst)

to obscure the very elements which make the object impossible. Escher takes a further step in this direction by concealing the ceiling behind arcades and the floor behind a balustrade. What remains of the impossible cuboid is shown in Figure 14. Above and below its skeletal framework Escher now builds solid, detailed blocks, with which he both reinforces the reality of the picture as a whole and at the same time accentuates the conflicting orientations of the top and bottom of the cuboid. Thus the upper storey appears to lie at right angles to the one below – an impression

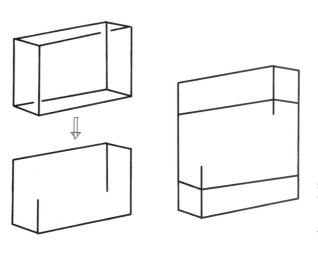

14 Analysis of the structure of Escher's "Belvédère" (cf. fig. 18), lithograph, 42.2 x 29.5 cm, 1958

heightened by the different directions in which the woman on the top floor and the man on the floor below are each gazing. A minimum of four pillars are necessary to connect the top and bottom planes of an impossible cube, whereby only two can be "impossible"; here, Escher uses eight pillars, six of them establishing impossible connections. The ladder leading from the floor to the ceiling represents another such connection, and one whose impossibility is underlined by the

two figures climbing its rungs: the lower figure sets off from inside the cuboid, while the upper figure has somehow arrived outside. Escher uses all these manipulations to infuse his picture with a greater degree of impossibility than that initially achieved by concealing contradictory elements. It is clear that he developed the composition with great care, in order to portray the wondrous nature of the impossible cuboid as realistically as possible.

Escher and Penrose

In a letter to his son Arthur of 24 January 1960, Escher described how the Penrose article first came to his notice. At the time, he was "working on the design of a new picture, which featured a flight of stairs which only ever ascended or descended, depending on how you saw it. Seen in the round, a winding staircase would normally take the shape of a spiral, vanishing into the clouds at the top and into hell at the bottom. Not so with my stairs: they form a closed, circular construction, rather like a snake biting its own tail. And yet they can be drawn in correct per-

spective: each step higher (or lower) than the previous one. A number of human figures are following the stairs in two directions. Those on one side toil ever upwards, while those on the other are trapped in a never-ending descent. I discovered the principle in an article which was sent to me, and in which I myself was named as the maker of various 'impossible objects'. But I was not familiar with the continuous steps of which the author had included a clear, if perfunctory, sketch, although I was employing some of his other examples."

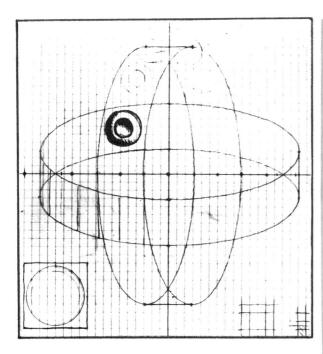

15 M.C. Escher, preliminary study for "Cube with magic bands"

16 M.C. Escher, "Cube with magic bands", lithograph, 30.9 x 30.9 cm, 1957

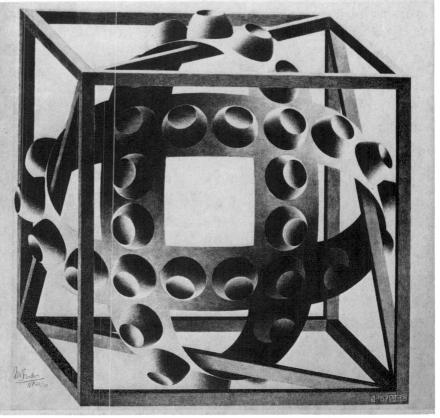

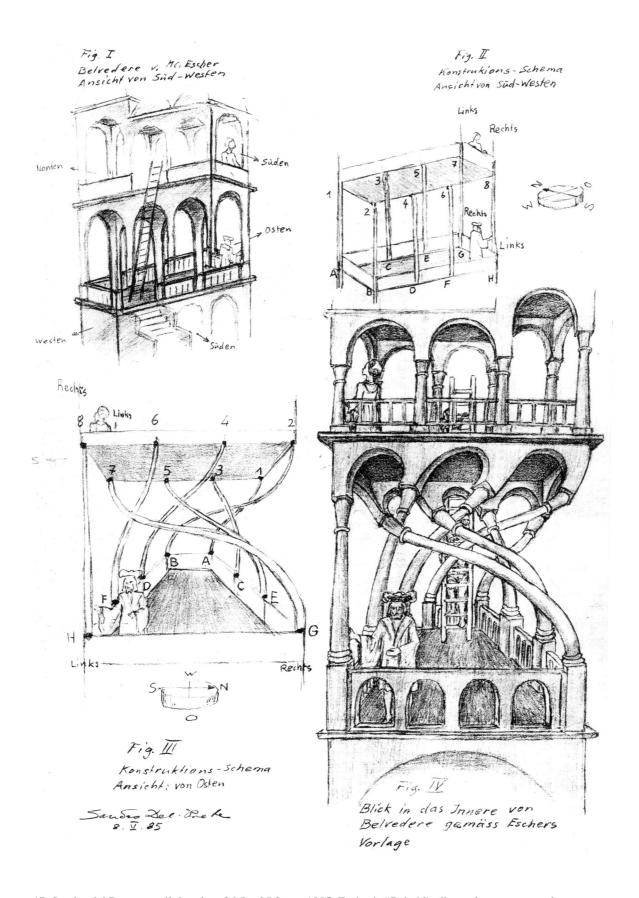

17 Sandro del Prete, pencil drawing, 36.5 x 25.2 cm, 1985. Escher's "Belvédère" may be seen as a coherent construction in which a number of connections are curved.

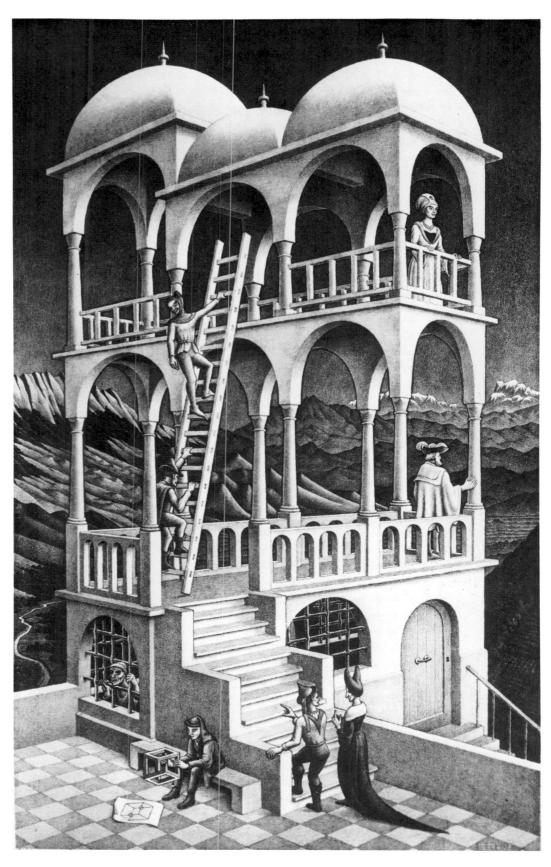

18 M.C. Escher, "Belvédère", lithograph, 46.2 x 29.5 cm, 1958

Escher's work provides no explicit evidence that he knew of the impossible tri-bar prior to reading the Penrose article. Nevertheless, the sketches for Cube with magic bands demonstrate that he was indeed preoccupied with similar concerns. But it was the endless stairs which captivated Escher above all else, despite the "perfunctory drawing". He subsequently (18 April 1960) wrote to the two Penroses: "A few months ago, a friend of mine sent me a photocopy of your article . . . Your Figures 3 and 4, the 'continuous flight of steps', were entirely new to me, and I was so taken by the idea that they recently inspired me to produce a new picture, which I would like to send you as a token of my esteem. Should you have published other articles on impossible objects or related topics, or should you know of any such articles, I would be most grateful if you could send me further details." Penrose responded with a letter of thanks and an article on a new type of impossible object. The picture which

Escher had sent was Ascending and descending (fig. 21), the least original of Escher's four pictures of impossible objects and no more than a "clothed" version of the Penrose drawing. Escher himself never understood how its impossibility actually arose. In *The Magic Mirror of M.C. Escher*, I offered an analysis of the picture on the basis of Escher's own explanations. Only years later did I realize that Ascending and descending as Escher interpreted it was not an impossible object, but rather a distorted figure which could very probably be built in three dimensions, whereas the Penrose stairs are truly impossible.

Escher houses his stairs on top of a building. As he understood it, it would be possible to wind strips of tape in a spiral around the exte-

19 (above) and 20 The underlying structure of Escher's "Ascending and descending" can be interpreted in two ways. Escher himself explained it in terms of Fig. 19, which cannot be described as an impossible object. I adopted the same explanation in my book, "The Magic Mirror of M.C. Escher".

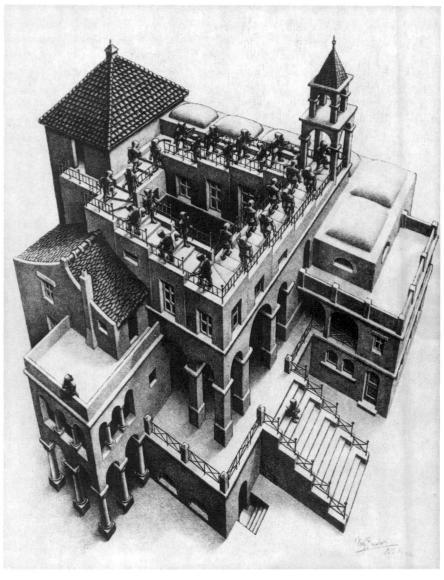

21 M.C. Escher, "Ascending and descending", lithograph, 32.5 x 28.5 cm, 1960

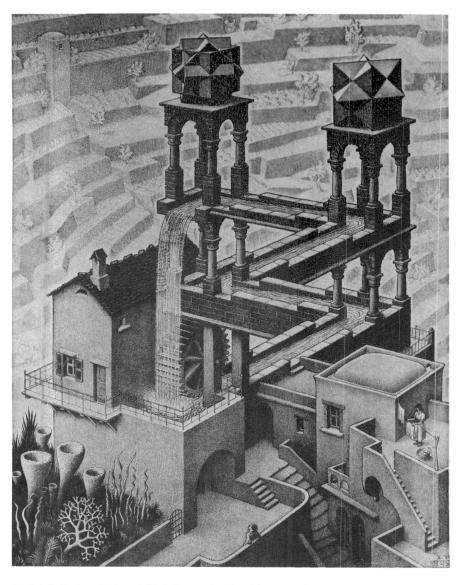

22 M.C. Escher, "Waterfall", lithograph, 38 x 30 cm, 1961

rior of this building. By means of a slight angling, uniformly distributed across every corner and plane, it would then be possible to create the illusion of a continuous flight of steps, as illustrated in Figure 19. At no point is there any gap in the staircase. In Figure 20, on the other hand, all four sides lie horizontal. The hatched strip should end at A, but by adding length B we create an (impossible) connection with strip C: this is the impossible object which is discussed in the Penrose article and which, executed as a model, produces a staircase with a gap in it. It is naturally impossible to tell from Ascending and descending which of the two methods it employs; what is clear, however, is that the difference between the possible and the impossible is very small in such a richly-detailed composition. Escher made true use of Penrose's tri-bar in his Waterfall lithograph of 1961 (fig. 22). Through a series of sketches, any one of which could have produced an attractive impossible object, he arrived at a tri-bar in a thoroughly natural-looking setting with highly realistic details. Geometric impossibility is here accentuated by physical impossibility. Escher organizes the whole into a perpetuum mobile of the first order: the water in his picture is made to drive a water wheel which is thus able to generate power from nothing!

23 M.C. Escher, sketches of impossible objects

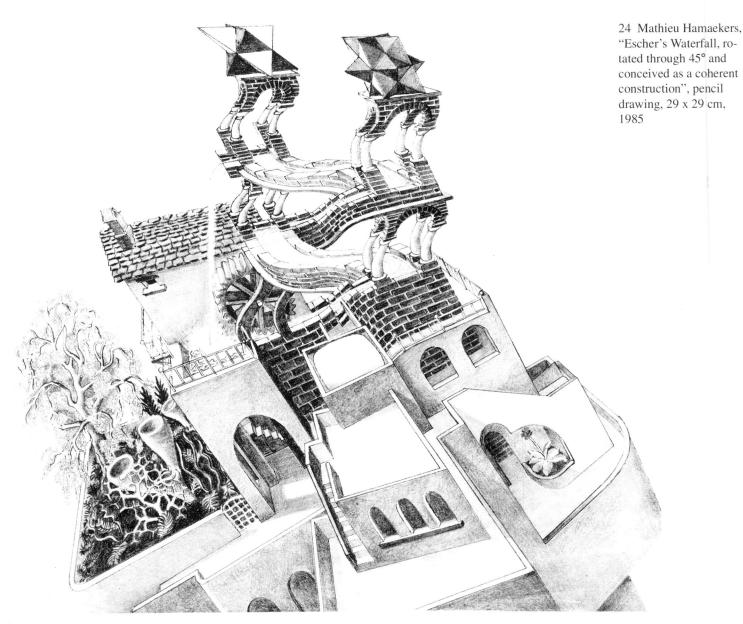

Waterfall was the last of the four impossible pictures which Escher completed. Having, in his opinion, now successfully depicted the peculiar nature of impossible objects, he returned to the subject to which he was irresistibly drawn and which he considered his personal speciality: the regular filling of planes. Escher was the first to draw an impossible

cube; he also knew how to visualize a number of other impossible objects in highly plastic, indeed almost narrative form. Perhaps his chief significance for impossible objects lies in the fact that, through his pictures, they have won greater popularity and international recognition as an enrichment to our visual world.

The devil's fork

Impossible objects with ambiguous contours, characterized by the fact that they cannot be coloured in (cf. fig. 25), were being created by Oscar Reutersvärd even before 1958. It was not until 1964, however, that attention was drawn to such objects in a short article by D.H. Schuster, dedicated to impossible objects of a type that soon became known as the "devil's fork" (article on page 81).

25 Oscar Reutersvärd, tri-seven-bar structure

Figure 26

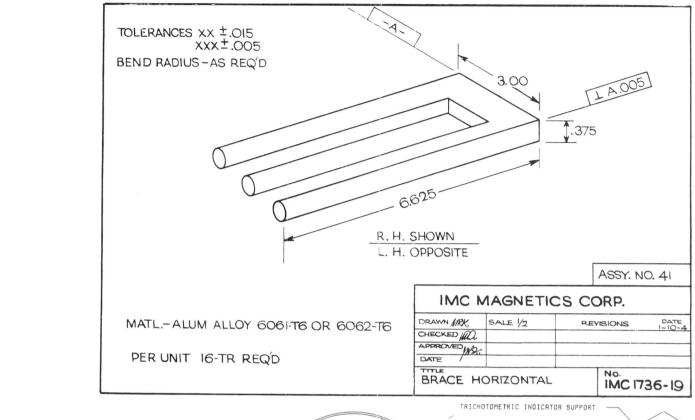

Figure 27

A new ambiguous figure: a chain joint/a horizontal brace

"The figure opposite [26], which recently appeared in an *Aviation Week and Space Technology* (80, 1964) advertisement, is shown here because, in my opinion, it is a matter of a new type of ambiguous figure. Unlike other ambiguous drawings and geometric figures – Jastrow's duck-rabbit, Hill's wife-and-mother-in-law, Botwinick's husband-and-father-in-law (a male counterpart to Hill's drawing), the Necker cube, the Schröder stairs and Mach's book – it is the shift in the optical focal point which plays a role in per-

ception and interpretation here. If the observer focuses on the left-hand side of the figure at reading distance, he sees three legs, and the right-hand side remains blurred and fuzzy; if he focuses on the right-hand side, he sees a U-shaped object, like a chain joint/horizontal brace. Only if he looks at the middle or slowly allows his view to pass over the figure does he come to realize that he is looking at an 'impossible object', as impossible as the illusory figures described by Penrose and Penrose and authors referring to them."

Drawings soon appeared of technically realistic variations upon the "devil's fork" theme (figs. 27 and 28). Reutersvärd's thorough understanding of such objects led him to

draw more complex structures, such as Figure 25, with three bars made to look like seven, and Figure 29, whose true nature as a "devil's fork" is less easily recognizable.

Going back in time

Although the history of impossible objects may confidently be said to have started in 1934, some had already appeared before this date. Some were intended as a passing joke, as in the case of Marcel Duchamp; others arose semi-consciously or unconsciously in a desperate attempt to reproduce stereographic elements in a satisfactory manner. These latter were formerly taken as perspective imperfections; today, however, we can appreciate them from an entirely new angle.

In 1916/17 Marcel Duchamp turned an advertisement for Sapolin, a well-known paint manufacturer, into a homage to his friend Apollinaire by omitting and adding various letters (fig. 30). He also transformed part of the bed frame, by means of a few strokes of white paint, into a – not entirely convincing – impossible tri-bar and four-bar structure. Duchamp himself never pursued this line any further. To find another example, we must travel back 150 years in time.

30 Marcel Duchamp, "Apolinère enameled"; corrected ready-made, 1916-17, Philadelphia Museum of Art

31 Giovanni Battista Piranesi, "Carceri, Plate XIV", revised edition, 1760

Piranesi's fourteenth prison

Giovanni Battista Piranesi (1720-78) was born in Venice. Although destined by his background and training for the architectural profession, in practice he was considerably more active as an etcher and engraver. He published over thirty books on architecture, chiefly polemic works, illustrated with hundreds of drawings of architecture in the neoclassical style. His vast oeuvre commands little interest today. One exception, however, is his series of Carceri - bizarre, fantastical and mysterious drawings of prison dungeons. Invenzioni capricci di carceri, a set of fourteen plates, first appeared in 1745 as the third part of his extensive publications. He subsequently revised all the plates, added two more and republished them in 1760 under the title Carceri d'invenzione (Imaginary Prisons).

Although fantastical depictions of prisons were not uncommon in those days, Piranesi's pictures stand out for the personal, original and powerful nature of their expression.

They show increasingly unreal, often impossible rooms in a style which goes beyond neoclassicism.

In *Carceri XIV*, Piranesi employed the contrast of multiple flat planes as one of the many means with which he consciously sought to create unusual, impossible spaces, without realising, however, that he had thereby achieved an entirely new manner of spatial contradiction.

A great deal has been written about his engravings and several authors have discussed the perspective impossibilities they contain. Some have even seen them as an application of non-Euclidean geometry, and Prof. J.H. van den Berg made them the basis of an important part of his "Metabletica of Matter." These pictures have little to do with non-Euclidean geometry, however. Although consciously striving after spaces which were difficult, if not impossible, to analyse, Piranesi was nevertheless dependent upon contemporary conventions of suggesting three-

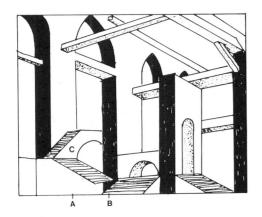

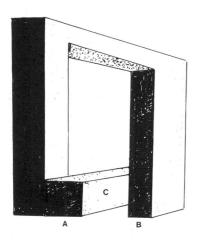

32 Analysis of Piranesi's "Carceri, Plate XIV"

dimensional space on a two-dimensional surface. He achieved his goal by deliberately including unclear and even contradictory spatial details. He thereby entered the territory of impossible objects, of which a number of examples can be identified in his *Carceri*. The most obvious is found in the above-mentioned fourteenth engraving, reproduced here in the revised version of 1760 (fig. 31). A long wall featuring three pointed arches starts from the left and runs across and beyond the centre of the picture. At point B

(cf. fig. 32) a section of this wall moves forward, whereby the lower half of the wall projects much further into the foreground than the section above. A multiple plane is thus created. Piranesi reinforces this effect by adding a flight of steps (C), which runs parallel to the wall and yet disappears behind it. I have illustrated these main features as accurately as possible, albeit diagrammatically, in Figure 32, through which the impossible object becomes instantly and clearly recognizable.

33 William Hogarth, "False Perspective", engraving, 1754

Hogarth's "false" perspective

Another picture which arose at about the same time, although very different in nature, is equally significant with respect to impossible objects.

The English painter and engraver William Hogarth (1697-1764) is famed as the leading

moralist amongst the English painters of the eighteenth century, a reputation which makes us frequently forget that he also executed a number of excellent paintings in the style of the Italian masters of his day. *False perspective*, a copper engraving from the year 1754

(fig. 33), would surely make him the "father of impossible objects", were it not for the fact that the very purpose of the composition was to demonstrate the types of mistake made by incompetent draughtsmen. As he makes clear in his caption: "Whoever makes a DESIGN without the Knowledge of PERSPECTIVE will be liable to such Absurdities as are shewn in this Frontispiece." Here, too, his moralizing tendencies – albeit not aimed, in this case, at the most popular sins of the day – come clearly to the fore.

The angler in the right-hand foreground is standing on a tiled ground whose incorrect vanishing-point makes it look like a vertical wall; this has nothing to do with impossible objects. Behind the angler, the boards of the shed wall compose a flat plane which combines two orientations at once (cf. Chapter 5). A sign hangs overhead from a braced pole, but the spatial configuration this suggests is contradicted by the fact that the pole and the brace are attached to two clearly separate buildings. The sign itself is partially obscured by trees which other spatial pointers place much further away. A woman leaning out of the window in the top right-hand corner is lighting a tramp's pipe with her candle. And yet the tramp is standing on a hill at least a hundred yards from her house . . .

34 Pieter Breughel, de-

tail from "The Magpie

on the Gallows",

Hessisches Landes-

museum, Darmstadt

The other "absurdities" we shall let rest. You

will perhaps have noticed that Hogarth at no point uses a precisely definable impossible object. Nevertheless, in composing his loose-knit impossible pictures, he employs the same spatial contradictions that we encounter in self-contained constructions of true impossible objects.

The Mural in Breda

In Breughel's *The Magpie on the Gallows* (1568; fig. 34), we see a clearly recognizable impossible four-bar. It would not surprise me to learn that the artist had quite consciously depicted something that is entirely out of the ordinary. In trying to make sense of the picture's strange spatiality, we are initially tempted to see the gallows in terms of warped beams. But if we attempt to draw a beam warped in this way, we do not obtain the same result as Breughel. Here, again, we seem to be dealing with a chance but conscious discovery.

It is inevitable that our current preoccupation with impossible objects should make us want to see such objects in historical works, however out of the question this may be. In some cases, nevertheless, the exercise is justified – as in the mural in St. Mary's church, or Grote Kerk, in Breda. Here, the testimony of an innocent witness from the period before 1934 lends credibility to the search for impossible objects from the past.

In 1902, a mural measuring 2.7 x 2.5 metres was discovered beneath the plaster in Breda's Grote Kerk. Remarkably well preserved, it shows an Annunciation from the hand of a fifteenth-century artist (cf. colour reproduction on p. 68). The scene is framed by two arches, supported by three pillars. The two outer pillars lie in the foreground, whereas the central pillar ends behind a table towards the back of the room. The result is a flat wall residing in both the front and rear pictorial

planes. The first art historian to write about the painting took note of this curious feature, describing it as "a perspectively-misplaced red pillar". However, the artist knew precisely why he was committing this supposed error: he clearly did not wish the scene to be cut in two by the pillar. (We know of other, similarly organized Annunciations, incidentally, in which the central pillar ends in the foreground.)

The colour reproduction on page 68 indicates the very poor condition of the mural today.

Circumstances favouring unintentional impossible objects

Man first began recording his visual impressions in pictorial form a very long time ago. Of course, all pictorial representations are by definition incomplete and selective, but during that initial (yet nevertheless lengthy) phase, only pictographic elements were reproduced. As objects began to be depicted in greater detail, however, so stereographic elements were added: human figures became three-dimensional, as did their immediate surroundings.

As the striving for a more accurate portrayal of space grew increasingly intense, so artists

discovered countless tricks and ploys with which to present a synopsis of perceived spatialities on a two-dimensional surface. This same progression can be traced in every culture in which representation has developed into "art", and in some cases it has led to the flowering of identical artistic ideals: Greece in the 5th century and Italy around 1425 both arrived at a centralized perspective, for example, while an axonometric perspective was preferred e.g. in Japan. We can expect to find unintentional impossible objects wherever an almost self-contained system of rep-

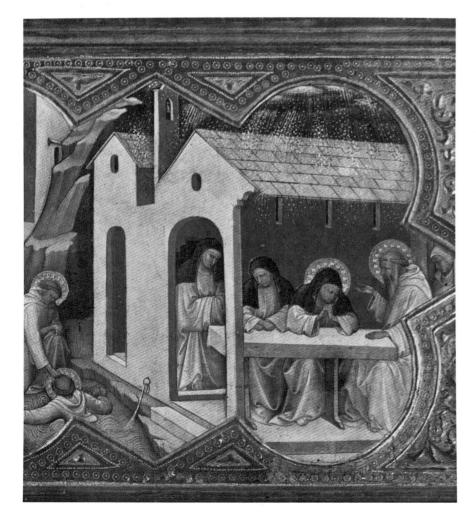

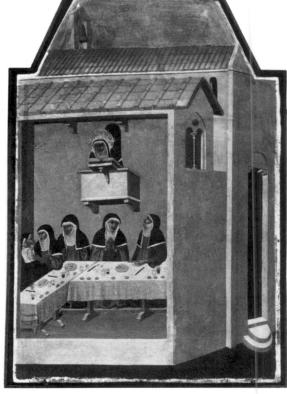

35 Lorenzo Monaco, detail from the predella of the "Coronation of the Virgin", 1413, Uffizi, Florence

36 Pietro Lorenzetti, altarpiece, first half of the 14th century, Uffizi, Florence

resenting space has been established. Such systems enable artists to reproduce spatial relationships with a high degree of accuracy; where they fail, this sometimes emerges in the form of spatial contradictions within the picture. Figures 35 and 36 show two works, one by Lorenzo Monaco and the other by Pietro Lorenzetti, dating from the period prior to the invention of centralized perspective. Both artists have managed to establish a spatially coherent floor, but neither has succeeded in incorporating the ceiling without ambiguity. In both cases, what is clearly an interior rear wall in the lower half of the picture appears at the top both to lie much fur-

ther away and to project forward – almost as if it were an exterior wall. The human figures thereby seem to sit both inside and outside the building at once. An even older painting from Ochrid (fig. 37) conceals a spatial contradiction in its portrayal of Mary's throne. The baldachin at the top is spatially coherent and is correctly related to the foot of the throne by the pillar on the left. This is not the case with the right-hand pillar: the artist has clearly shied away from overlapping the figure of Mary, and a spatial contradiction has arisen. The oldest impossible object currently known to us is a miniature from the 11th century (cf. p. 68).

Impossible objects as a sign of cultural change

Centralized perspective, together with the form of perception which accompanies it, represents a binding rule governing the representation of space which we cannot simply abandon without a second thought. We have lived with its maxims for five and a half centuries and judge all representations according to perspective criteria.

Around 1900 a number of new trends began to emerge within the arts. Of the many characteristics distinguishing these movements, one of the most striking was the rejection of traditional spatial representation. One relatively well-defined movement which subsequently emerged, and which became known as Op (or Optical) Art, concerned itself with optical effects and examined the particular way in which our brain processes information. The fact that Op Art is generally dismissed as a passing phenomenon in the history of art reflects first and foremost the selectivity of those writing about art, many of whom have failed to recognize the fact that Op Art is based on the workings of our awareness of living. Op Art has nevertheless become a widely-acknowledged concept within the applied arts and the world of advertising.

While impossible objects demonstrate points of contact with Op Art, it is well possible that they attract interest for more profound reasons. There is no suggestion of any rejection of the laws of spatial representation; on the contrary, impossible objects not only accept and on occasion infringe such laws, but indeed exploit them to create a taut spatiality. The future will show whether the widening interest in impossible objects is indeed more than merely a short-lived artistic experiment. Even today, however, it can be argued that we are concerned here not just with an artistic statement, but rather with a fundamental revision of Western thinking and experience. In 1934 the time was not yet ripe for the work of Oscar Reutersvärd; barely 25 years later, Escher's images captivated broad sections of the public. Escher's style of drawing was comfortably conventional, and thus it was not his manner of expression which attracted such widespread interest, but his sensational subject matter: the exploration of the functioning of our brain. Impossible objects are not the exclusive property of art, however, nor do they belong primarily to the world of mathematical science. Impossible objects can be created amateurishly and inexpertly, and yet still exert a fascination even for those with no head for geometrical formulae. They radiate an aura of self-revelation which directly appeals to a newly-acquired human sensibility. Impossible objects are a sign of this cultural change.

Misunderstandings surrounding impossible objects

Science has many theories which also appeal strongly to a lay public – the "black holes" which have captured the general imagination in our own times are a case in point. Einstein's theory of relativity, the fourth dimension, and non-Euclidean geometry similarly remain very popular. Unfortunately, what remains after the simplifications of third-hand popularization does little justice to the precisely-localized scientific content of the original theory. Some authors have thus been prompted to link the phenomenon of "impossible objects" to scientific concepts shrouded in mystery.

In his – highly recommendable – introduction to Reutersvärd's second book, *Omöjliga figurer i färg*, Carlo Bresti examines in detail attempts to create four-dimensional figures. He thereby arrives at the conclusion that, in this respect, impossible objects represent a breakthrough in art: "As the twentieth century's flight from three-dimensionality has long since taken us down a one-way street to the regions of two-dimensionality, so the art of the next century will flee in the opposite direction, into the realm of the fourth dimension, where continuous steps and triangles with angles totalling 270 degrees will be common accessories."

This has no foundation: even if we incorporate the fourth dimension, a continuous flight of stairs still remains an impossible object, while even in the fourth dimension the angles of a triangle total precisely 180 degrees.

The search for a four-dimensional equivalent of an impossible object is nevertheless valid. Indeed, Roger Penrose began looking in 1976, but published nothing on his results. Scott E. Kim (who corresponded with Penrose on the subject) produced an article in 1978 in which he gave a detailed description of an impossible four-dimensional tri-bar, together with instructions on how to reproduce it in three dimensions. Although this "four-dimensional drawing" (drawing in the fourth dimension involves a reproduction in three dimensions!) perhaps means little without the detailed accompanying description of how it arose, we have here reproduced an il-

37 Annunciation, Byzantine icon, early 14th century, National Museum, Ochrid

lustration of a wire model constructed from it (fig. 38). We are also currently waiting for the *Continually ascending staircase in four dimensions* promised in the same article.

We have already noted that Professor J.H. van den Berg sought to establish parallels between Piranesi's *Carceri* and non-Euclidean geometry. Reutersvärd does the same when writing about his own impossible objects.

Non-Euclidean geometry was similarly one of the topics which arose in the course of my correspondence with the Belgian artist Mathieu Hamaekers. In connection with his superb models of impossible objects, constructed out of curved, twisted bars (cf. Chapter 7), he wrote: "The methods I have developed are based on the geometries of Riemann and Lobachevski. It would be possible to give every culture its own aesthetic, because non-Euclidean modelling offers an infinite number of possibilities. It is important that each culture should be able to express its individuality even in the twentyfirst century. This same modelling can also be a compromise between the organic and the mathematical."

While most of us have a vague notion of the fourth dimension, the precepts of non-Euclidean geometry demand closer examination.

Euclid based his geometric system on five axioms (propositions which, although undemonstrated, are accepted as self-evident). Axioms are an indispensable condition of any system of logic, for each proof must be built either upon the preceding proof or upon a proposition (premise) — in this case, Euclid's axioms. Axioms must be used sparingly, in order that something which might have been proved by preceding axioms should not itself be made an axiom.

The fifth Euclidean axiom occupies a special position. It can be formulated as follows: "Through a point P, which does not lie on a given line l, it is possible to draw, in the plane in which both l and P lie, a single line which runs parallel to l."

Up until the first quarter of the last century, leading mathematicians were more or less convinced that the fifth axiom could be proved with the help of the other axioms, although every attempt in this direction failed. In 1829, Lobachevski showed that dropping the fifth Euclidean axiom resulted in an entirely different geometry. He replaced the fifth axiom by the thesis that an infinite number of lines can be drawn through P which run parallel to line 1. However much this axiom may appear to contradict our everyday experience, it was nevertheless possible to deduce from it a geometry without inner contradictions. A quarter of a century later, Riemann appeared on the scene with a geometry in which Euclid's fifth axiom was replaced by the postulate that no single line can be drawn through a point P outside the line 1 which is parallel to line 1.

In elaborating these geometries further, we find that their fifth axioms each have different consequences. Thus in Euclid's geometry, the sum of the angles of a triangle is always 180 degrees. In Lobachevski's geometry, the angles of a triangle always total less than 180 degrees, while Riemann's geometry produces triangles whose angles always total more than 180 degrees. We must emphasize, however, that all this has little or nothing to do with impossible objects, nor

with their spatial realization in the form of models. For while their geometrical models can be described precisely in Euclidean terms, the impossible objects themselves defy definition even in non-Euclidean geometries. They continue to owe their fascination and "possibility" – their reality, in other words – to the manner in which our visual system functions.

In the field of logic, too, attempts have been made to establish a connection between impossible objects and paradoxes. If we take the term "paradox" in its broadest sense, we can speak without hesitation of logical and visual paradoxes. In this case, impossible objects surely fall into the category of visual paradoxes.

Concentrating upon the structure of a logical (perhaps even linguistic) paradox, however, will certainly not lead to a better understanding of impossible objects. M.J. Cresswell has attempted to define impossible objects using the categories of logic. Although an interesting approach, it casts no new light on their nature. From the literature upon which he draws, moreover, it is clear that he had little opportunity to orientate himself within the fields of the functioning of the visual system and research into impossible objects. In his conclusion, he simply expresses the hope that new light may be shed on the problems from the point of view of logic and semantics, and by none other than . . . impossible objects!

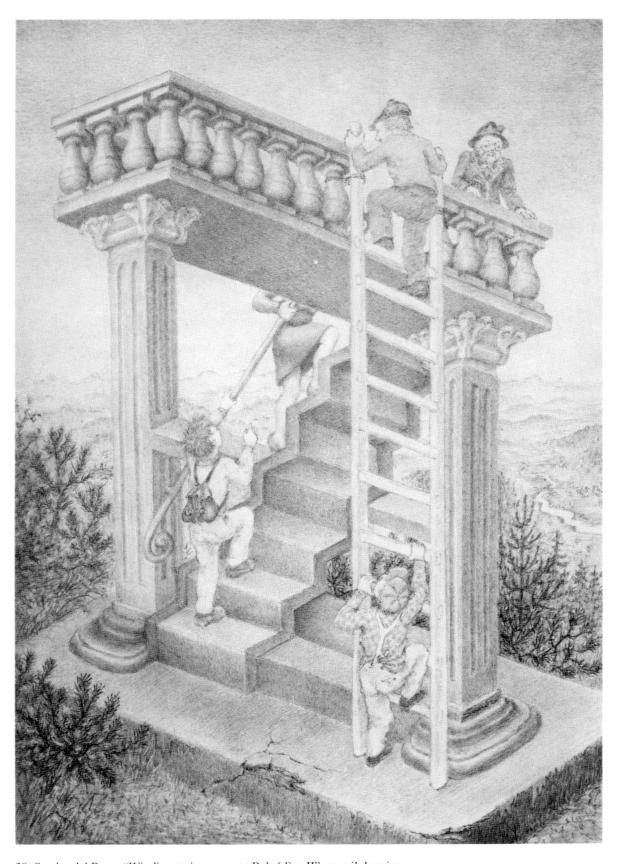

39 Sandro del Prete, "Winding staircase up to Belvédère II", pencil drawing

7 Models

Of course it is impossible to build a real-life, three-dimensional model of an impossible object; if you could, it wouldn't be one!

When we talk of a model of an impossible object, we mean a three-dimensional object which can be made to look like an impossible object if viewed or photographed from a certain angle. Such a model, incidentally, bears no similarity to the impossible object which is perceived by the EYE. Figure 1 shows a photograph of an impossible four-bar in which the true nature of the model is revealed by a mirror. It is patently clear that no similarity exists between the object and the image in the mirror.

As the first impossible objects became known, people lost no time in trying to make models of them. One of the first such models, very popular in its day, was the *Crazy crate*, a model of Escher's impossible cube produced by American opthalmologist Cochran out of two separate pieces.

For almost every impossible object we can invent a number of different models. Figure 2 demonstrates how we continue to see one and the same triangle, ABC, however differently oriented its lines in space. The lines themselves can assume all sorts of different forms and be broken or curved – projected onto our retina, they always supply the same image.

If we take bars instead of lines and trim their ends appropriately, the EYE perceives their spatial arrangement as an impossible tri-bar.

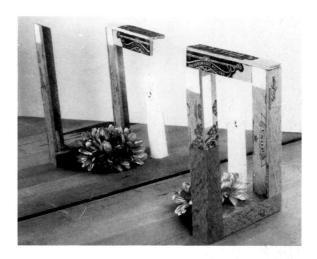

1 Bruno Ernst, photograph of an impossible four-bar and its reflection in the mirror.

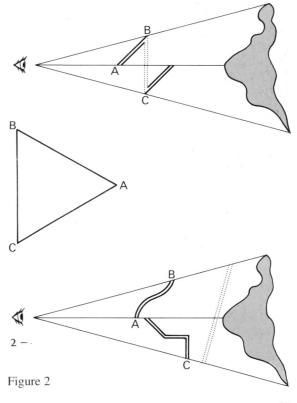

The Ames transformation

The way in which three-dimensional constructions acquire, through their projection onto the retina, a spatial coherence which does not accord with their actual spatial arrangement we shall call the "Ames transformation", and the result the "Ames image". Every model of an impossible object produces, by means of the Ames transformation, an Ames image in the form of an impossible object, although this naturally does not mean that all Ames images are impossible objects.

The majority of models are very obvious and hence less interesting. It is possible to apply certain stipulations to the Ames arrangement, however, to make it more challenging. We may thus insist that it should be as simple as possible, for example, or that it should form a closed figure, or that the arrangement itself should have an attractive geometric form, etc.

The following illustrations offer a selection of models; explanatory notes are provided in the accompanying captions.

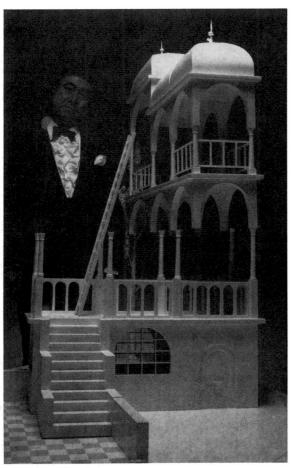

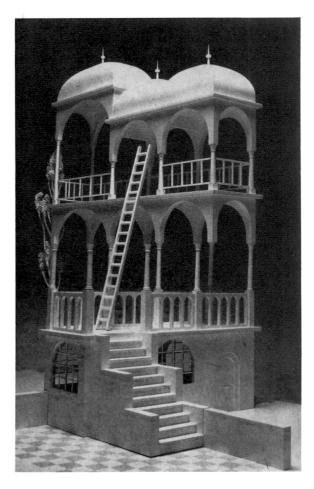

3 Shigeo Fukuda, models of Escher's Belvédère

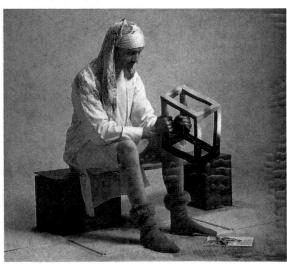

4 Mathieu Hamaekers pictured with an impossible cuboid; the model contains a number of curved bars.

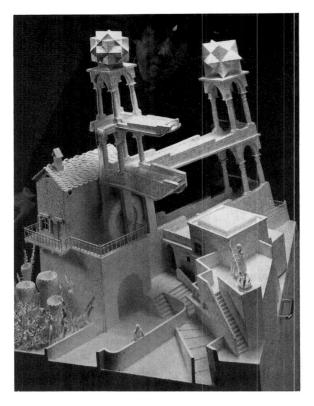

5 Shigeo Fukuda, model of Escher's "Waterfall", photographed from an angle revealing the gaps in the model.

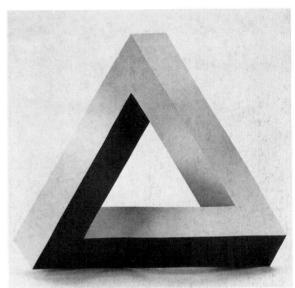

6 Mathieu Hamaekers, model of an impossible tri-bar; front view

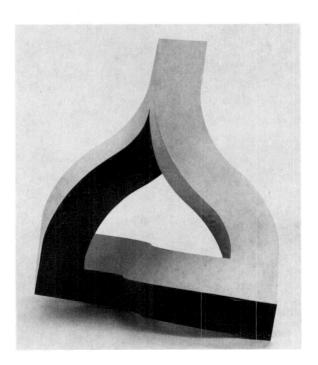

7 The same model rotated through 45°

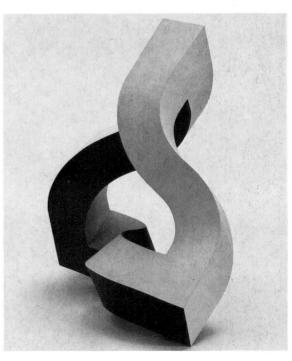

8 The same model rotated through 90°

Bibliography

Further reading on impossible objects and ambiguous figures:

- B. d'Amore, F. Grignani, Pitture, Sperimentali e Graphic Design, Commune di Reggio Emilia, 1979
- M. Anno, *Strange Pictures*, Tokyo: Fukuikan Shoten, 1968; French edition: *Jeux de constructions*, L'école des loisirs, Paris, 1970
- M. Anno, *The Unique World of Mitsumasa Anno: Selected Illustrations 1969-1977*, Kodansha Ltd., Tokyo, 1977
- F. Attneave, "Multistability in perception", *Scientific American*, vol. 225, no. 6, 1971, pp. 62-71 and December 1971, pp. 91-99
- T.O. Binford, "Inferring surfaces from images", *Artificial Intelligence*, vol. 17, no. 1, pp. 205-244
- I. Chakravarty, "A generalized line and junction labeling scheme with applications to scene analysis", IEEE *Trans. on Pattern Analysis and Machine Intelligence*, vol. PAMI-I, no. 2, 1979, pp. 202-205
- Challenge to Geometry Oscar Reutersvärd, Zenon Kulpa – Impossible figures, Art Museum of Lodz, Lodz 1984, exhibition catalogue
- M.B. Clowes, "On seeing things", Artificial Intelligence, vol. 2, no. 3, 1971, pp. 79-116
- M.B. Clowes, "Scene analysis and picture grammars", in: F. Nake and A. Rosenfeld, eds., *Graphic Languages (Proc. IFIP Working Conf. on Graphic Languages*, Vancouver, 1972), Amsterdam 1972, pp. 70-82; also in: *Machine Perception of Patterns and Pictures*, Institute of Physics, London and Bristol, 1972, pp. 243-256
- T.M. Cowan, "The theory of braids and the analysis of impossible figures", *Journal of Mathematical Psychology*, vol. 11, no. 3, 1974, pp. 190-212
- T.M. Cowan, "Supplementary report: braids, side segments, and impossible figures", *Journal of Mathematical Psychology*, 1977, 16, pp. 254-260
- T.M. Cowan, "Organizing the properties of impossible figures", *Perception*, vol. 6, no. 1, 1977, pp. 41-56
- T.M. Cowan and R. Pringle, "An investigation of the cues responsible for figure impossibility", *Journal of Experimental Psychology; Human perception and performance*, vol. 4, no. 1, 1978, pp. 112-120
- K. Critchlow, *Order in Space*, The Viking Press Inc., New York, 1970
- S.W. Draper, "The Penrose triangle and a family of related figures", *Perception*, vol. 7, 1978, pp. 283-296
- S.W. Draper, "The use of gradient and dual space in line drawing interpretation", *Artificial Intelligence*, vol. 17, no. 1, 1981, pp. 461-508
- B. Ernst, *The Magic Mirror of M.C. Escher*, Tarquin Publications, Norfolk, 1985
- B. Ernst, *Adventures with Impossible Figures*, Tarquin Publications, Norfolk, 1986

- G. Falk, "Interpretation of imperfect line-data as a 3-D scene", *Artificial Intelligence*, vol. 3, no. 2, 1972, pp. 101-144
- C. French, "Computer art a load of quasi-spherical objects?" PAGE (*Computer Arts Society quarter-ly*), no. 44, 1980, pp. 1-12
- M. Gardner, "Of optical illusions from figures that are undecidable to hot dogs that float", *Scientific American*, 222, 1970, pp. 124-127
- R.L. Gregory, "Visual Illusions", *Scientific American*, November 1968, pp. 48-58
- R.L. Gregory, "The confounded eye", in: R.L. Gregory and E.H. Gombrich, eds., *Illusion in Nature and Art*, Duckworth, London/Scribners, New York, 1973, pp. 49-95
- J. Guiraud and P. Lison, *Systematique des figures reversibles*, Gestetner, Brussels, 1976
- A. Guzman, Computer recognition of three-dimensional objects in a visual scene, MIT Artificial Intelligence Laboratory, Cambridge (MA), 1968
- A. Guzman, "Decomposition of a visual scene into three-dimensional bodies", AFIPS *Proc. of FJCC*, vol. 33, Thompson Book, New York, 1968, pp. 291-304; also in: A. Gresselli (ed.), *Automatic interpretation and classification of images*, Academic Press, New York, 1969, pp. 243-276
- W.F. Harris, "Perceptual singularities in impossible pictures represent screw dislocations", *South African Journal of Science*, 1973, 69, pp. 10-13
- J. Hochberg and V. Brooks, "The psychophysics of form: reversible perspective drawings of spatial objects", *American Journal of Psychology*, vol. 73, 1960, pp. 227-254
- D.A. Huffman, "Impossible objects as nonsense sentences", in: B. Melzer and D. Michie (eds.), *Machine Intelligence* 6, Edinburgh University Press, 1971, pp. 295-323
- D.A. Huffman, "A duality concept for the analysis of polyhedral scenes" in: E.W. Elcock and D. Michie (eds.), *Machine Intelligence* 8, Ellis Horwood, Chichester/Halsted, New York, 1977, pp. 475-492
- D.A. Huffman, "Realizable configurations of lines in pictures of polyhedra", in: E.W. Elcock and D. Michie, eds., *Machine Intelligence* 8, Ellis Horwood, Chichester/Halsted, New York, 1977, pp. 493-509
- D.A. Huffman, "Surface curvature and applications of the dual representation", in: A.R. Hanson and E.M. Riseman (eds.), *Computer Vision Systems*, Academic, New York, 1978, pp. 213-222
- W.G. Hyzer, "Plenty of chances to go astray in photographic interpretation", *Photo Methods for Industry*, January 1970, pp. 20-24
- T. Kanade, "A theory of Origami world", *Artificial Intelligence*, vol. 13, no. 3, 1980, pp. 279-311

5 Shigeo Fukuda, model of Escher's "Waterfall", photographed from an angle revealing the gaps in the model.

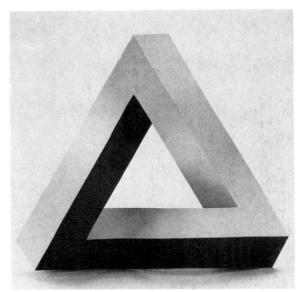

6 Mathieu Hamaekers, model of an impossible tri-bar; front view

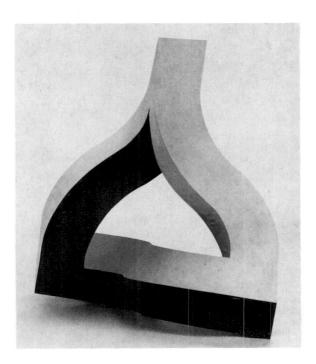

7 The same model rotated through 45°

8 The same model rotated through 90°

Bibliography

Further reading on impossible objects and ambiguous figures:

- B. d'Amore, F. Grignani, Pitture, Sperimentali e Graphic Design, Commune di Reggio Emilia, 1979
- M. Anno, *Strange Pictures*, Tokyo: Fukuikan Shoten, 1968; French edition: *Jeux de constructions*, L'école des loisirs, Paris, 1970
- M. Anno, *The Unique World of Mitsumasa Anno: Selected Illustrations 1969-1977*, Kodansha Ltd., Tokyo, 1977
- F. Attneave, "Multistability in perception", *Scientific American*, vol. 225, no. 6, 1971, pp. 62-71 and December 1971, pp. 91-99
- T.O. Binford, "Inferring surfaces from images", *Artificial Intelligence*, vol. 17, no. 1, pp. 205-244
- I. Chakravarty, "A generalized line and junction labeling scheme with applications to scene analysis", IEEE *Trans. on Pattern Analysis and Machine Intelligence*, vol. PAMI-I, no. 2, 1979, pp. 202-205
- Challenge to Geometry Oscar Reutersvärd, Zenon Kulpa – Impossible figures, Art Museum of Lodz, Lodz 1984, exhibition catalogue
- M.B. Clowes, "On seeing things", *Artificial Intelligence*, vol. 2, no. 3, 1971, pp. 79-116
- M.B. Clowes, "Scene analysis and picture grammars", in: F. Nake and A. Rosenfeld, eds., *Graphic Languages (Proc. IFIP Working Conf. on Graphic Languages*, Vancouver, 1972), Amsterdam 1972, pp. 70-82; also in: *Machine Perception of Patterns and Pictures*, Institute of Physics, London and Bristol, 1972, pp. 243-256
- T.M. Cowan, "The theory of braids and the analysis of impossible figures", *Journal of Mathematical Psychology*, vol. 11, no. 3, 1974, pp. 190-212
- T.M. Cowan, "Supplementary report: braids, side segments, and impossible figures", *Journal of Mathematical Psychology*, 1977, 16, pp. 254-260
- T.M. Cowan, "Organizing the properties of impossible figures", *Perception*, vol. 6, no. 1, 1977, pp. 41-56
- T.M. Cowan and R. Pringle, "An investigation of the cues responsible for figure impossibility", *Journal of Experimental Psychology; Human perception and performance*, vol. 4, no. 1, 1978, pp. 112-120
- K. Critchlow, *Order in Space*, The Viking Press Inc., New York, 1970
- S.W. Draper, "The Penrose triangle and a family of related figures", *Perception*, vol. 7, 1978, pp. 283-296
- S.W. Draper, "The use of gradient and dual space in line drawing interpretation", *Artificial Intelligence*, vol. 17, no. 1, 1981, pp. 461-508
- B. Ernst, *The Magic Mirror of M.C. Escher*, Tarquin Publications, Norfolk, 1985
- B. Ernst, *Adventures with Impossible Figures*, Tarquin Publications, Norfolk, 1986

- G. Falk, "Interpretation of imperfect line-data as a 3-D scene", *Artificial Intelligence*, vol. 3, no. 2, 1972, pp. 101-144
- C. French, "Computer art a load of quasi-spherical objects?" PAGE (*Computer Arts Society quarter-ly*), no. 44, 1980, pp. 1-12
- M. Gardner, "Of optical illusions from figures that are undecidable to hot dogs that float", *Scientific American*, 222, 1970, pp. 124-127
- R.L. Gregory, "Visual Illusions", *Scientific American*, November 1968, pp. 48-58
- R.L. Gregory, "The confounded eye", in: R.L. Gregory and E.H. Gombrich, eds., *Illusion in Nature and Art*, Duckworth, London/Scribners, New York, 1973, pp. 49-95
- J. Guiraud and P. Lison, *Systematique des figures reversibles*, Gestetner, Brussels, 1976
- A. Guzman, Computer recognition of three-dimensional objects in a visual scene, MIT Artificial Intelligence Laboratory, Cambridge (MA), 1968
- A. Guzman, "Decomposition of a visual scene into three-dimensional bodies", AFIPS *Proc. of FJCC*, vol. 33, Thompson Book, New York, 1968, pp. 291-304; also in: A. Gresselli (ed.), *Automatic interpretation and classification of images*, Academic Press, New York, 1969, pp. 243-276
- W.F. Harris, "Perceptual singularities in impossible pictures represent screw dislocations", *South African Journal of Science*, 1973, 69, pp. 10-13
- J. Hochberg and V. Brooks, "The psychophysics of form: reversible perspective drawings of spatial objects", *American Journal of Psychology*, vol. 73, 1960, pp. 227-254
- D.A. Huffman, "Impossible objects as nonsense sentences", in: B. Melzer and D. Michie (eds.), *Machine Intelligence* 6, Edinburgh University Press, 1971, pp. 295-323
- D.A. Huffman, "A duality concept for the analysis of polyhedral scenes" in: E.W. Elcock and D. Michie (eds.), *Machine Intelligence* 8, Ellis Horwood, Chichester/Halsted, New York, 1977, pp. 475-492
- D.A. Huffman, "Realizable configurations of lines in pictures of polyhedra", in: E.W. Elcock and D. Michie, eds., *Machine Intelligence* 8, Ellis Horwood, Chichester/Halsted, New York, 1977, pp. 493-509
- D.A. Huffman, "Surface curvature and applications of the dual representation", in: A.R. Hanson and E.M. Riseman (eds.), *Computer Vision Systems*, Academic, New York, 1978, pp. 213-222
- W.G. Hyzer, "Plenty of chances to go astray in photographic interpretation", *Photo Methods for Industry*, January 1970, pp. 20-24
- T. Kanade, "A theory of Origami world", *Artificial Intelligence*, vol. 13, no. 3, 1980, pp. 279-311

- T. Kanade, "Recovery of the three-dimensional shape of an object from a single view", *Artificial Intelligence*, vol. 17, no. 1, 1981, pp. 409-460
- Z. Kulpa, "Oscar Reutersvärd's exploration of impossible lands", in 150 Omöjliga figurer Oscar Reutersvärd, Malmö Museum, Malmö, 1981, exhibition catalogue
- Z. Kulpa, "Are impossible figures possible?", Signal Processing, vol. 5, no. 3, 1983, pp. 201-220
- Z. Kulpa, "Putting order in the impossible", in: E. Térouanne (ed.), *Proc. 16th Meeting of the European Mathematical Psychology Group, (Montpellier, 8-11 Sept. 1985)*, Université Paul Valéry, Montpellier, 1985, pp. 127-144
- A.K. Mackworth, "Interpreting pictures of polyhedral scenes", *Artificial Intelligence*, vol. 4, 1973, pp. 121-137, vol. 4, 1977, pp. 54-86
- A.K. Mackworth, "Model-driven interpretation in intelligent vision systems", *Perception*, vol. 5, 1976, pp. 349-370
- A.K. Mackworth, "How to see a simple world: an exegesis of some computer programs for scene analysis", in: E.W. Elcock and D. Michie (eds.), *Machine Intelligence* 8, Ellis Horwood, Chichester/Halsted, New York, 1977, pp. 510-537
- R. Nevatia, *Machine Perception*, Prentice-Hall, Englewood Cliffs NJ, 1982
- B. Raphael, *The thinking computer Mind inside matter*, W.H. Freeman, San Francisco, 1976
- O. Reutersvärd, *Omöjliga figurer*, Bokförlaget Doxa AB, Bodafors, 1982; Dutch edition: *Onmogelijke figuren*, Meulenhoff/Landshoff, Amsterdam 1983
- L.G. Roberts, "Machine perception of three-dimensional solids", in: J.T. Tippet et al. (eds.), *Optical and Electro-optical Information Processing*, MIT Press, Cambridge (MA), 1965, pp. 159-197
- J.O. Robinson and J.A. Wilson, "The impossible colonnade and other variations of a well-known figure", *British Journal of Psychology*, vol. 64, no. 3, 1973, pp. 363-365
- P.V. Sankar, "A vertex coding scheme for interpreting ambiguous trihedral solids", *Computer Graphics and Image Processing*, vol. 6, 1977, pp. 61-89
- R. Shapira and H. Freeman, "A cyclic-order property of bodies with three-face vertices", IEEE *Trans. on Computers*, vol. C-26, no. 10, 1977, pp. 1035-1039
- K. Sugihara, "Dictionary-guided scene analysis based on depth information", in: *Report on Pattern Information Processing Systems* No. 13, Electrotechnical Laboratory, Tokyo, 1977
- K. Sugihara, "Picture language for skeletal polyhedra", *Computer Graphics and Image Processing*, vol. 8, 1978, pp. 382-405
- K. Sugihara, "Studies on mathematical structures of line drawings of polyhedra and their applications to scene analysis", *Res. Electrotech. Lab.*, no. 800, 1979
- K. Sugihara, "Classification of impossible objects", *Perception*, vol. 11, 1982, pp. 65-74
- K. Sugihara, "Mathematical structures of line drawings of polyhedrons toward man-machine communication by means of line drawings", IEEE *Trans. on Pattern Analysis and Machine Intelligence*, vol. PAMI 4, no. 5, 1982, pp. 458-469

- K. Sugihara, *An algebraic approach to shape-from-image problems*, Res. Note RNS 83-01, Dept. of Information Science, Faculty of Engineering, Nagoya University, 1983
- E. Térouanne, "Impossible figures and interpretations of polyhedral figures", *Journal of Mathematical Psychology*, vol. 27, 1983, pp. 370-405
- E. Térouanne, "On a class of 'impossible' figures: a new language for a new analysis", *Journal of Mathematical Psychology*, vol. 22, no. 1, 1983, pp. 24-47
- E.B. Thro, "Distinguishing two classes of impossible objects", *Perception*, vol. 12, no. 6, 1983, pp. 733-751
- V. Vasarely and M. Joray, Vasarely, Editions du Griffon, 1971
- D. Waltz, "Understanding line drawings of scenes with shadows", in: P. H. Winston (ed.), *The Psychology of Computer Vision*, McGraw-Hill, New York, 1975, pp. 19-91
- W. Whiteley, "Realizability of polyhedra", in: *Structural Topology*, vol. 1, University of Montreal Press, Montreal, 1979, pp. 46-58
- P.H. Winston (ed.), *The Psychology of Computer Vision*, McGraw-Hill, New York 1975
- A.W. Young and J.B. Deregowski, "Learning to see impossible", *Perception*, vol. 10, 1981, pp. 91-105
- J.M. Yturralde, "Ambiguous structures", in: D.W. Brisson (ed.), *Hypergraphics Visualizing Complex Relationships in Art, Science and Technology*, Westview Press, Boulder (CO), 1978, pp. 177-185

Impossible objects are phenomena which cannot exist but which we can see all the same. They captivate the imagination and tantalize the viewer with their mysterious fascination. They illuminate something of the remarkable process of vision, as our brain is forced to accept a situation of visual conflict which it never encounters in the outside world. Amongst the first to concern themselves with impossible objects were Oscar Reutersvärd and M.C. Escher.

When Bruno Ernst – the pseudonym of J.A.F. Rijk - began preparing an exhibition of the work of these artists in 1983, it emerged that many other artists all over the world had also discovered impossible and ambiguous objects as a source of inspiration. The publication of more than one hundred articles since 1970 is incontrovertible evidence of the close attention which the subject has attracted amongst theoreticians, too. This interest prompted the author to undertake an exhaustive study of the field, in the course of which he encountered no less than fifty artists working with impossible objects. The results of his investigations are found in this book, in which Bruno Ernst guides the reader, with the aid of numerous examples and illustrations, through the wonderful world of optical illusions and visual realities.

The Dutch author Bruno Ernst has closely followed the development of the works of M.C. Escher from 1956 onwards, and has published his observations in, amongst others, *The Magic Mirror of M.C. Escher* and *Leven en werk van M.C. Escher*.